MAKING STAGE COSTUMES

A PRACTICAL GUIDE

With most affectionate thanks to
Dick Tuckey, Caroline Smith, Rex Doyle, Gerard Boynton,
Tamara Malcolm, Turtle Key and Chris Baldwin who, at
wide-spaced times, took brave risks by encouraging and
using successive changes of direction
in my work.

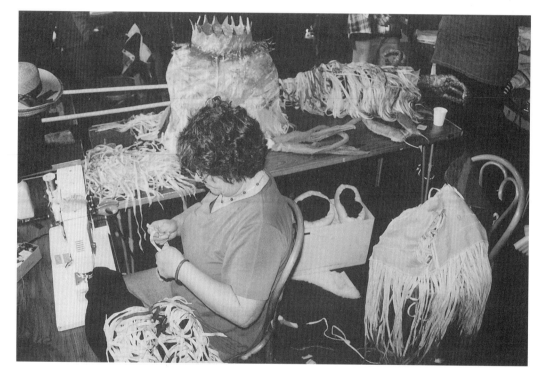

Work in the wardrobe. *Photo: Hannah Bicât*

MAKING STAGE COSTUMES

A Practical Guide

Tina Bicât

The Crowood Press

First published in 2001 by
The Crowood Press Ltd
Ramsbury, Marlborough
Wiltshire SN8 2HR

British Library Cataloguing-in-Publication Data
A catalogue record for this book is available from the British Library.

ISBN 1 86126 408 9

Acknowledgements
I would like to thank Kate Bicât for organizing my chaos with such good humour and for testing the technical exercises with Francesca Byrne and Debbie Taylor, Gabrielle Hennig for her trouser pattern, and Hannah Bicât and Robin Cottrell for their photographs. I also thank David Hare for his Foreword, Carrie Bayliss, Ali King, Jonathan McDonnell, Sue Pittaway and Haibo Yu, and all the staff and students of the Drama department of St Mary's University College at Strawberry Hill for their encouragement. And most of all, I thank everyone who uses my ideas.

All photographs by the author, except where individually credited otherwise.

Line illustrations by Graham Kent

Designed and edited by Focus Publishing, Sevenoaks, Kent

Printed and bound in Great Britain by
J. W. Arrowsmith, Bristol

CONTENTS

FOREWORD

by David Hare

It's something of a mystery why the British love theatre so much, and why they're so good at it. Perhaps it's something in our character which can only be liberated by pretending to be something we're not. It often seems as if we relish the basic act of deceit which is at the heart of the enterprise. Or maybe, more simply, we just like dressing up.

For theatre to thrive it needs a very distinctive mix of the idealistic and the practical. Putting on a play needs ambition, of course, but it also needs expertise. Reading Tina Bicât's remarkably sane, remarkably informed book has reminded me of how rich the British theatre is in people who manage to combine these qualities in equal measure.

Tina's purpose is to help people who are planning to mount plays on very small budgets, to teach them how to make the best of what is available without having to compromise the vision and the high standards they have set for themselves in their own minds. For someone like me, who has worked in the theatre all their life, it's humbling to read *Making Stage Costumes – A Practical Guide* and realize how much I don't know – how much, in fact, as a playwright and director, I've depended on a bank of knowledge and enthusiasm of which I've not always been aware.

I've known Tina for over thirty years and I've seen her both at work in the wardrobe and at the moment when the results of her work hit the stage. She seems to me the very best kind of theatre professional – the person who is always steady, always imaginative and who, above all, understands and relishes the profound collaborative art of knowing exactly when to stick to their own ideas and when to listen to other people.

The book is what I would have expected from Tina – illuminating, readable and thorough. It takes the mystery out of costume making, but it enhances the magic. It's a pleasure to recommend it.

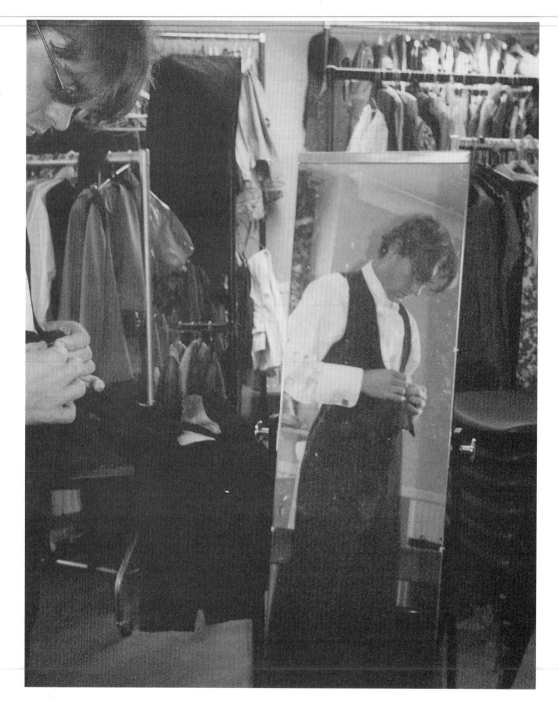

An actor trying his costume at a fitting in the wardrobe.

INTRODUCTION

THE COSTUME MAKER

This is not a book for experienced costume makers with time, money and skill at their disposal. It is for designers, students, teachers, actors and anyone who needs and wants to make costume for performance but has little money or technical expertise. Thread, stiffening, boning and fastenings can overstretch a small budget and are not seen by the audience in the same way as are colour, silhouette and the way a costume and actor move together in the light. There are many excellent books about period pattern cutting and historically accurate costume construction. This book will lead you to them and make you feel brave enough to plunge into them when skill and budget allow it.

If you look at a costume made by a professional costumier, you will see immediately the amount of skill and experience necessary to create such a garment. It takes a long time and a great deal of practice to acquire this skill. It can also take quite a lot of money. This book will show you how to get by, and learn while you are working. Television and film have accustomed us to a historically accurate approach to costume making, but imaginative and practical work can lead to exciting results that give both audience and actor a full sense of period and style.

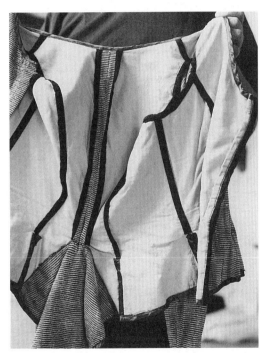

The inside of a bodice, showing seams ready for boning. Photo: Hannah Bicât

A costume maker needs a calm, practical temperament combined with a vivid imagination and a strong constitution – it can be very hard work. You must be able to put forward your opinions and be prepared to defend them when others disagree. You are more likely to be

able to do this effectively if your research prior to production and observations during rehearsals have been thorough. Theatre is a group activity. Much of your contact time with the other members of the company will be spent in trying to understand their ideas and feelings and translate them into reality. To succeed in this you must be patient and open-minded and listen with great concentration in order to understand what they are feeling, as well as what they are saying. Many inspirational concepts start in a muddled blur of emotion and chat. Time, talk and tolerance are needed to arrive at a clear picture.

Never be daunted by the unexpected demands of each job. You will be amazed how much you can achieve if you approach each new challenge with vigorous optimism. There will be times when you will be so exhausted that you can hardly speak and when your fingers ache with cutting and sewing. You will be covered with glue, paint and sweat and brought close to despair by your tussles with the budget. There will be moments of agonized frustration as you wait for an actor to be free for a fitting when there are a million and one things you could be doing in your workroom. However, there will also be wonderful moments when you find the ideal piece of cloth, cut the perfect pattern, or watch the shoulders of the actor relax and settle in confidence as he looks at himself in the mirror wearing the costume you have made.

Best of all is to sit in the auditorium during a dress rehearsal and see the pictures that have been simmering in your head and boiling in your dreams come to life on the stage. There is no pleasure like it and it never stales.

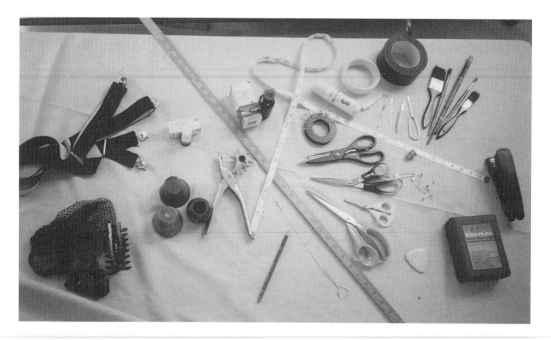

Some of the tools for general wardrobe use including a magnet for dropped pins and a first aid kit.

THE TOOL BOX

These are the tools you will use most often and will find it difficult to manage without. The rest you can acquire when occasion demands.

- The best dressmaking shears you can afford. Use them only for cloth and never let them out of your sight. They should feel comfortable in your hand, not too heavy to control, and be very sharp. As you become more experienced, you will pattern cut directly into the cloth and the scissors must follow your thoughts and eye smoothly and without effort. This may seem a lot of chat about a pair of scissors but they are your most essential tool.
- Strong scissors for items such as card, paper, hair and leather. Lend these to desperate stage managers – never the dressmaking shears. Scissors blunt quickly if they are used for anything other than cloth.
- Small sharp-pointed scissors
- Sharp-bladed knife or scalpel
- Unpicker
- A strong and reliable sewing machine. You will need a zigzag stitch. Other stitch types will be useful but are not so necessary. Better a simple, strong machine than a complicated, unreliable one.
- Iron and ironing board
- Muslin ironing cloth
- Spray bottle for extra steam when pressing.
- Tape measure and a yardstick or metre long rule
- Small hammer
- Chalk and pencils. Always check that they will not mark the cloth permanently.
- Pins, and a magnet to keep them under control.
- Safety pins – lots, all sizes
- Threads. Big reels are more economical. You will need extra-strong thread for heavy work.
- Needles – several sizes. You can buy bladed (glover's) needles, which make lighter work of hats and heavy fabrics. Spare machine needles in several sizes including the strongest.
- Paint brushes – several sizes
- An awl or other spike on a handle
- Extension lead
- A pinboard for drawings, measurements and the running shopping list
- A hanging rail and a dressmaker's dummy are useful, but you can manage without them at a pinch.

First Aid

Always keep a small first aid kit in the wardrobe. It is often the first port of call for the wounded and blistered. Make sure you know where to find help in cases of more serious accident. Theatres and institutions have accident books where details should be noted in case of future complications.

THE WORKROOM OR WARDROBE

Workrooms vary as much as costume makers, theatres and houses. You do not need huge tables and perfect equipment to make wonderful costumes, although it does help. Much excellent cutting is done on the floor, and the skill of the cutter matters more than the quality of the equipment. The workroom will probably double as a storeroom, so try not to let the storage space overwhelm the workspace. Position the work areas to make the best use of light, both natural and

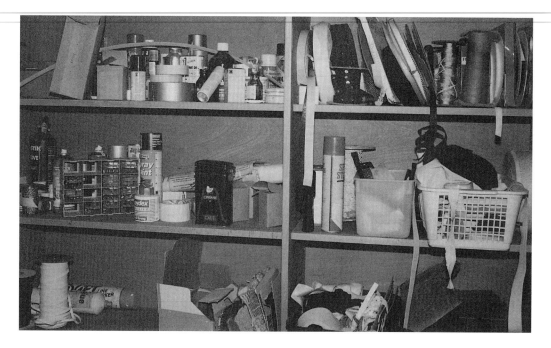

Shelves for haberdashery in the workroom.

artificial. It may help to have an extra light, which you can move as necessary.

- The sewing machine table should be large enough to have a space on the left-hand side. This will be needed to support the considerable weight of the cloth you will sometimes need to sew.
- The chair or stool should be a comfortable height or you will get backache when work is fast and furious.
- Iron and ironing board should be permanently available – you will use the iron as often as the sewing machine.
- You will definitely need a mirror and it should be as large as possible. An actor at a fitting should be able to see himself from top to toe. You will use its reflected view constantly to give yourself a more distant impression of the work in progress.

No one can tell you how to organize your workroom. It is a most personal space and the best way to arrange it is by trial and error. Once you have established an arrangement that suits you, you will be able to re-create it in the most unlikely and unsuitable venues and feel at home immediately.

The wardrobe in a traditional theatre is usually at the top of the building, where after climbing many cruel flights of stone steps, you will find space ordered and equipped for the job. However, you will often have to make do with a dressing room, storeroom, classroom or barn when you are working in venues that were not built as theatres. It can take all your ingenuity to make a good workspace out of these rooms but allow time in even the tightest schedule to do this. Ropes and hooks, or even nails banged into a board, can provide hanging space and tables and shelves can be

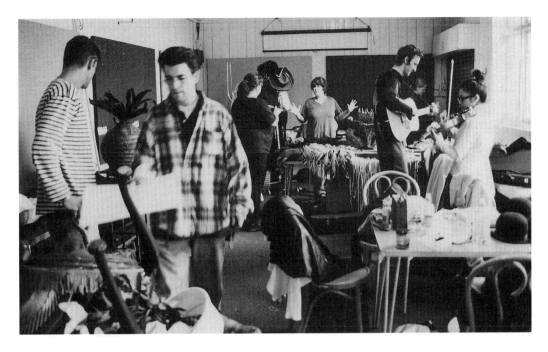

A temporary wardrobe, dressing room and band room set up in a park shed. Photo: Hannah Bicât

rigged up to hold your equipment and stores. A large, temporary cutting table can be made by balancing an old door covered with hardboard or a large sheet of chipboard on desks or smaller tables. Ask the production manager or stage manager for help. They may have access to hidden storerooms, and if they know what you need in the way of rails or mirrors, they may help you to borrow them from other parts of the building.

This room will be yours for the duration of the job. It should feel welcoming and be as suitable as you can make it for the way you like to work. You will have more fun and do a better job if you are happy in your workroom.

It may be your responsibility to clear the area safely in an emergency, so make sure you know the fire drill for each venue and check that any emergency exits are unlocked and open easily.

Emergency costume rail made from an old gas pipe and rope. Photo: Hannah Bicât

How to Use This Book

The book falls into the following three sections.

Section 1 – Chapters 1–3
This describes the general work of the costume maker, pre-production strategy, managing the budget and the way life will be when rehearsals start. It will tell you of the difficulties and delights you may encounter when shopping and help you to make productive use of the time before the audience sees the play.

Section 2 – Chapters 4–6
This section provides technical help and advice. It will show some of the shortcuts that can be used over and over again, and explain which techniques are most useful for quick, strong work. If you do not have much sewing experience it will be worth working through these chapters to build a base of useful skills. If you have leant how to sew and have made clothes before, skip through and pick out useful tips. Theatrical dressmaking is not always the same as real-life dressmaking, but the formal skills you have learnt can be easily adapted once you know how.

This section will show how to adapt commercial patterns for theatrical use and give some tried and tested shortcut ideas for patterns. These will be particularly suitable for creating a basic costume, which can be easily added to and altered for different productions. They have been chosen for their simplicity and adaptability and should give you a trouble-free start in cutting and fitting. The exercises will give you the confidence to start cutting and sewing costumes and make the many exciting and more complicated books on historical pattern cutting seem less daunting.

Section 3 – Chapters 7–12
This section describes basic costumes and accessories. It will help you to use modern clothes to suggest period and cope with the demands of large casts and low budgets. It also deals with less conventional costume work – with animals, monsters and abstract characters such as wind or cholera. It will help to unravel the knotty needs of costumes for youth theatre work and community plays, and describes the work of the wardrobe at the dress parade, the technical and dress rehearsals, and the first night.

You will find tip-boxes throughout that offer snippets of useful advice.

'He' and 'she' are used throughout the book in an arbitrary manner because, of course, both sexes do all jobs in a theatre.

1 PRELIMINARY RESEARCH AND PREPARATION

Workers in the costume department often find themselves trying to create an impression of a past era. When creating costumes for a period play on a small budget, you must find some way to represent the age and make it recognizable to your audience without the resources available to more affluent companies. If this makes you feel you are compromising too much, remember that the most historically correct costume, cut with every seam in its historically correct place, is not going to be looked at with expert eyes –you are making for an audience, not a fashion historian or another designer.

However intricate your research, there will always be an 'expert' somewhere who will tell you that the George Medal was not awarded posthumously in 1941, or that no aristocrat sported a fob watch in Northumberland during Ascot week in the 1880s. There will also be someone who thinks that everyone before the 1920s wore a corset and crinoline. This does not mean that it is a waste of energy to seek out information – it is vital and will engross much of your pre-production time. But the quest for historical accuracy should be kept in perspective.

PERCEPTION

Costumiers must keep their eyes open and remember what they see. You can never predict when some nugget of visual information will be needed but you can hardly whip a notebook out at a wedding and start sketching the odd aunt – she must be stored in the memory for future use. It is helpful to keep

A genuine Victorian bodice showing a complication of beautiful seams.

15

scrapbooks and notebooks especially for this purpose. Develop a way of organizing the information so that it is easy to access.

You can improve your observation skills and visual memory with practice. A good exercise for honing them is to spend an hour or two hanging around a big and busy station. There you will find a cross-section of society, dressed in their everyday clothes and gathered conveniently for you to study. Their appearance will be loaded with clues for you to unravel. Try to guess their work and the purpose of their journey. See how their shoes affect the way they walk. What are they trying to show the world as they cross the concourse in front of you? It may be the same thing as you are trying to show the audience. Find someone who is settled in one place and try to memorize his clothes (dark glasses can be very helpful if you feel uncomfortable about staring at people). Look away, sketch the person, and the blanks in your memory will become apparent. Look back and see the points you have missed. Notice which colours attract the eye. Notice how subtle changes in clothing, such as scarves or the crispness of ironing, give messages to the onlooker. Notice how the stance of a person can be affected by the objects they are carrying and give a particular message. In a play, these would be costume props, and it would be your job to provide them.

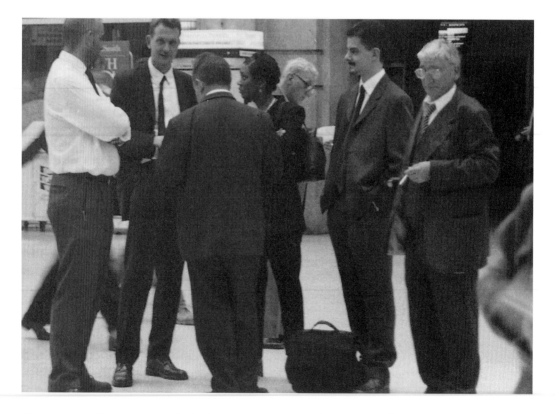

Scene at a station – everyone in dark grey suits but revealing their differing characters by the way they wear them. Photo: Hannah Bicât

With exercise, your visual abilities will improve and help you when you are translating a design to reality, shopping for cloth, assembling parts of a costume and showing the audience a convincing picture.

THE IMPORTANCE OF SILHOUETTE

You may have noticed when you are trying to recognize someone on a beach or at a far distance that it is headgear or unusual hair shape that you identify. The information contained in the bare outlines of hats can tell us the era, age, social position and job of the wearer.

Similarly, it is possible to recognize a person in a portrait that is nothing more than a silhouette or outline, and it is quite interesting to prove this by trying it out with shadows of profiles.

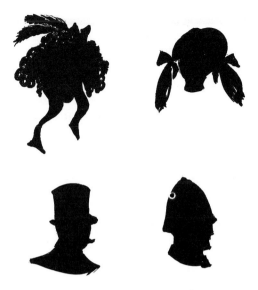

In these four silhouettes, devoid of colour or detail, you and the audience can find information about status, age, period and profession.

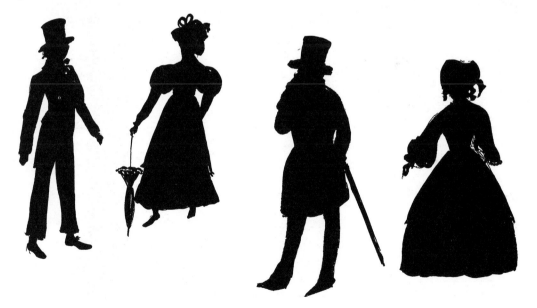

Silhouettes of costumes from the early and late nineteenth century showing how the outline of the sleeves, coat tails and skirt sets the period.

Whilst the detail of the costume enriches the picture by showing us features such as status and character, the examples of the silhouettes of clothes from different periods show how much the audience can gather about period from the shape alone. They may identify Robin Hood's time instead of medieval, or say Dickens instead of Victorian, but the message will have been understood. It is remarkable that such a small amount of visual information can show us so much, and demonstrates how necessary it is to be careful not to give the wrong message.

An interesting exercise is to create a frieze of the outlines of styles spanning the last millennium. You will notice how the cut of the clothes develops. Begin your frieze in the tenth century and reproduce the most typical shapes at fifty-year intervals. You will notice that in the earlier years, most of the clothes were draped, using simple shaping techniques. This was partly for economy: sheep were valuable, and shearing, spinning and weaving by hand, laborious. Dyes took time and skill to prepare and apply and the resulting cloth was not to be wasted by careless or extravagant cutting. Status might be reflected as much by the amount of cloth used as by jewels and richness of colour. When you begin to cut costumes, you will discover how useful many of the draping and shaping techniques used by the tailors of the Middle Ages are to the novice costume maker of today.

RESEARCH

The avenues for research are endless, punctuated by fascinating and useful byways and equally fascinating, time-consuming and useless cul-de-sacs. People have always been judged, and ranked in society, by their clothes. Men and women of the past showed their wealth and status by a richness of cloth, cut and decoration as surely as we do today with our designer labels and trainers. The more you know about the time in which the play is set, the more you will understand the messages given by the clothes.

As soon as you know about the job, before you even read the play, find out when and where it is set and make sure you have a clear picture in your mind of the style of clothes that were worn. It is easier to see the characters as real people if you can imagine how they spent their days. The type of work they did, the climate, the amount of money they had and the rules of the society they lived in will have a marked effect on their clothes. Collect information relevant to the project in a folder.

Research

Thorough research will build the right runway for your flights of fancy. The pictures that will light your imagination when you read the play, story or outline will only be applicable if you have prepared your mind with relevant information. Without it you may well fly high and beautifully, but in the wrong direction and your ideas will be useless.

SOURCES

Costume and textile collections

These are the real thing and therefore the most valuable first-hand source of information. In a well-displayed costume collection you will be able to walk round the exhibits and peer at every seam, flounce and button. You will also be able to stand back and see which details are most marked from a distance. Half close your eyes and squint a bit to get an impression of the detail that will be picked up from the back row of the gallery.

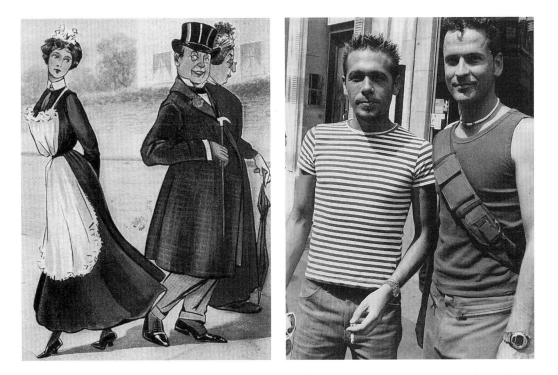

Men about town separated by a century but using the same signals of fashionable accessories to give messages to the onlooker. Photo: Hannah Bicât

The same is true of textile collections. Sometimes, by appointment, you may be allowed to take a closer look at the exhibits and obtain access to items not on display. Further insight into the exhibits may often be obtained by talking to the museum curator.

Chatting

If the period you are studying falls within living memory and you can find someone who lived then and is happy to talk about it, you are on to a winner. Try showing an actual piece of costume or a photograph relating to the time you are researching to someone who might have worn it in their late teens or early twenties. People tend to remember clothes they wore at that age with more accuracy than those they wore in later years. It will jog their memory into recalling long-forgotten, costume-related facts and incidents. You will be given an understanding of the clothes, and how and when and by what sort of people they were worn. No other research will give you these personal revelations in such gossipy detail. The great advantage to the costumier is that you can ask questions on points that particularly interest you.

Museums, art galleries, photographs and documentaries

These are all most useful, but they can be misleading and need to be supplemented by background reading to get at the truth. It may look from the sculpture as if the ancient

Talking about a photograph or portrait with its subject will jog the memory into recollection.

Greeks lived in a monochrome world, but their clothes blazed with as much colour as ours.

Make sure you know whether you are looking at the real thing or an impression by an artist of another era. Portraits painted during the lifetime of the sitter may provide correct information, but if painted years after their death, give only the artist's impression of the time – and there is no reason to suppose he knows any more about it than you do. The information gathered from a film made in 2000 of an event in 1810 will be subject to contemporary influences. You can prove this by looking at a film made in 1940 and a film made today of the same subject. The costume and make-up in the earlier one will be recognizably dated to modern eyes. To eyes fifty years hence, our interpretation of the same subject will look equally bizarre.

Books

There are many wonderful books about historical costume and pattern cutting and it is almost always possible to find an illustration in one of them of the subject you are seeking. Anyone who is seriously interested in costume will assemble a library of beloved books to which they will refer over and over again. Biography and social history provide both pictorial evidence and written accounts of life in past eras, and will give an idea of the way people lived in their clothes and how they wore them. You can find many intriguing facts hiding in collections of letters or diaries.

This, for instance, is how Pepys tells us he looked in 1663. 'This morning I put on my best black cloth suit trimmed with scarlet ribbon, very neat, with my cloak lined with velvet and a new beaver [hat] which altogether is very noble, with my black silk knit canons [breeches] I bought a month ago.' He also writes later in his diary that 'it is a wonder what will be the fashion after the plague is done as to periwigs, for nobody will dare to buy any hair for fear of the infection – that it had been cut of the heads of people dead of the plague'. Latham, R. (ed.), *The Illustrated Pepys* (Bell and Hyman, 1978)

Books dealing with etiquette and advice to housewives are full of useful facts. This is how Mrs Beeton in her celebrated book of household management describes the dress of a housemaid at the turn of the nineteenth century, '...her morning attire should be a print gown and simple white cap and apron. In the afternoon her dress should be a simply made black one, relieved by white collar, cuffs and cap and a pretty, lace-trimmed bib apron'. This particular outfit is illustrated on page 19.

Make notes, sketches and copies as you go, noting the source as well as the fact in case you need to return for another look.

All this can become so engrossing that it is easy to lose sight of your objective which is to learn how to produce costumes that actors will wear to give the audience the message you want. There will often be a choice between authenticity and practicality. Our hero, in the baggy-bottomed breeches so suitable for long hours in the eighteenth century saddle, may not have the same appeal to the modern audience as he would in breeches of a less authentic but sexier pattern. It can be difficult for both designer and maker to let the hard-won knowledge go. Not, however, so hard for the actor who may well prefer the less authentic but more attractive and comfortable costume.

THE COSTUME PLOT

Before you begin work on the costumes, you will need to have made a costume plot. This is a chart that will tell you at a glance which characters appear in each scene, what costumes and accessories to provide, and when the costume changes occur. Alterations to the scripted information which will happen in rehearsal can be marked in as the work proceeds. This chart, if kept up to date, will help to make sure that everything is in place before the dress parade or technical rehearsal. Checking through it with actors at fittings will bring to light any information that has not reached the wardrobe via the stage manager or director. The basis of the costume plot will come directly from the script.

A Doll's House by Henrik Ibsen
Written in 1879, this extract from Act I takes place in the Helmer's house. The author's stage directions describe a sitting room and tell us that it is winter.

(A bell rings in the hall; shortly afterwards the door is heard to open. Enter NORA, humming a tune and in high spirits. She is in out-door dress and carries a number of parcels; these she lays on the table to the right. She leaves the outer door open after her, and through it is seen a PORTER who is carrying a Christmas Tree and a basket, which he gives to the MAID who has opened the door.)

NORA. Hide the Christmas Tree carefully, Helen. Be sure the children do not see it till this evening, when it is dressed. *(To the PORTER, taking out her purse.)* How much?

PORTER. Sixpence.

NORA. Here is a shilling. No, keep the change. *(The PORTER thanks her and goes out. NORA shuts the door. She is laughing to herself, as she takes off her hat and coat. She takes a packet of macaroons from her pocket and eats one or two; then goes cautiously to her husband's room and listens.)* Yes, he is in. *(Still humming, she goes to the table on the right.)*

HELMER. *(calls out from his room)* Is that my little lark twittering out there?

The action at the beginning of the play gives several facts which are relevant to costume.

- Nora comes in from outside in a hat and coat which she takes off onstage.
- The coat needs a pocket with an opening wide enough for her to extricate the bag of macaroons she is eating onstage. Check the size of the bag with the stage manager so that it will fit in the pocket.
- The porter is carrying a basket. Will the wardrobe or props department provide the basket?
- Nora gives the porter money from her purse. Helmer gives her some money later in the scene after she has taken off her coat. She will presumably put it in the same purse. Does she need a pocket in her dress for this purse and how big should it be?
- Though there is no mention in the stage directions of her gloves, our knowledge of the etiquette of the period informs us that

she would have been wearing them. Also, we know that it is Christmas and winters in Norway are cold and snowy.

All this information is gleaned from a few lines of script and needs to be written into the costume plot. You may find that some item of clothing or an accessory is not drawn on the designs, in which case you should ask the designer for a sketch or a description of the way she would like it to be.

Example of a costume plot
This is a costume plot for some of the characters who appear in *A Doll's House*.

Placing Pockets

A right-handed actress will prefer a pocket on the right-hand side unless the action dictates otherwise. To check pockets end up in the right place, ask the actor to put his hand in an imaginary pocket when wearing the costume and mark the spot. He will find the best place instinctively.

Name	Act I – daytime	Act II – late afternoon the next day	Act III – the following evening
Nora	Day dress with pocket, coat with pocket, hat, gloves and purse	Dress, cloak, hat. In box – fancy-dress, muff, gloves, flesh-coloured stockings and shawl all as worn in Act III Hair falls down onstage	Fancy-dress costume as seen in Act II Quick change (2 minutes?) to day dress Cloak, hat, bag and ring
Porter	Outdoor clothes, basket		
Maid	Indoor dress	Indoor dress	'half dressed' (night clothes?)
Helmer	Indoor clothes, purse in pocket, coat and hat	Coat, hat and suit	Evening dress, domino (a cloak) Pocket for keys

It might be that the director does not want the costumes or naturalistic period accessories and plans to re-interpret the macaroons. However, you will know what the script calls for and you should be able to re-adjust the costume plot as all is revealed during rehearsal. Much of the information you need will be hidden in the dialogue, not in the stage directions and you must read carefully to winkle it out.

2 Structure of the Company and Pre-Production Work

A performance needs at least one performer and someone to watch the show. This is a very bald and dull way of describing the endlessly varied worlds on the stage. The work can be subdivided to employ crowds or contracted to a lone performer, and the work of each one of them affects the work of the others.

On a big-budget production there will be a long list of painters, makers, stage crew and administrators working with the director and his assistants. A very low-budget show may only have director, cast, and stage manager

Some productions are the result of an artistic director's need to find a balanced combination of work to fill a season, others stem from one person's overwhelming longing to produce a particular performance. The performance may be naturalistic, surreal or epic and performed in a theatre, a street or a school. Highly trained, world-famous companies rehearse with plenty of time in an ideal venue and a lavish (but never lavish enough) budget. Quite often, though, it is a couple of people at the kitchen table with twenty-three quid in the teapot. It makes no difference to the basic urge to show an audience an idea; nor does it necessarily make a difference to the audience's enjoyment of the

piece. Once you have accepted the job and jumped into the production team, work and ideas will start to materialize.

The Beginning

There are some facts you should know before you start. You cannot begin to think practically unless you know the budget, the venue and the time available to do the work. Whether you are the designer, the maker, or both, the first meeting will be more informative if you have absorbed some background information about the history and clothes of the period. Then at least you know that your ideas will be appropriate. The first thing to do is to read the script, or the outline if the work is not yet written. Then read it again. And, if you need to, read it again and again, to place the characters and pattern of events firmly in your head. Anything you can find out that will add to your understanding of the play and the director's theatrical interests and previous productions will help in discussions.

Directors will often talk to designers long before the start of rehearsals. They need the designer's particular talents to show the audience their vision of the play. It can take much discussion and drawing to reach the

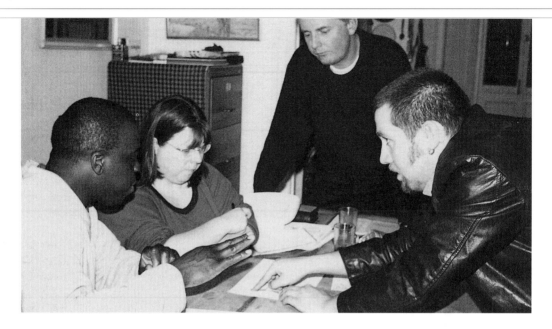

Designer discussing a drawing at an informal pre-production meeting.

mutual understanding that will make the partnership flourish. Nothing really good can be achieved without this understanding and much time and money will be wasted.

The order of work, once you start the job, will run something like this:

- Reading the script
- Early research
- Talking to the director
- Sorting out timing and budget
- Pre-production meetings, planning, shopping and ordering of supplies
- First company meeting and read through, talk or workshop
- Shopping, cutting, fittings during rehearsal
- Final fittings
- Dress call or costume parade
- Technical rehearsals
- Dress rehearsals
- First night

There are exceptions, and there will be more or less in the diary according to company, venue and budget. If you are making but not designing the costumes, you will usually become involved later in the process, though the making of some of the costumes may start before the rehearsals. The timing depends on the size of the project, whether there is sufficient time, space and money to allow an extended period of work, and how much the costume designer wants or needs your involvement in the planning stages.

Try to get the actors' measurements as soon as they are cast. The production manager may do this. If not, send them a form with a list of the measurements you need, or contact their agent who will have their details. Hope springs eternal on an actor's tape measure, so make allowances when you cut your cloth unless you have taken the measurements yourself.

The Production Team

This is a list of the key workers. It gives an idea of the work they do with particular reference to the costume department. It can be nothing more than a rough guide as every company is different. Regardless of how many people are involved, the basic jobs are the same. One person may represent all these people.

Production managers

Production managers and their departments sort out the money and the technical planning of a production. Details of employment, the budget and providing some programme information are their responsibility. They will organize supplies of cash for your production shopping, and inform you of any firms with whom the company has accounts or who give generous discounts. Talk to them in good time if the budget is in serious need of review or if orders need to be paid for in advance.

Directors

Directors translate the written word into a performance or lead the devising of the piece in rehearsal with the help of actors, designers and stage crew. They bind the work of the entire company into a cohesive whole. There may also be music, dance, fight, and movement directors.

Designers

Designers of set, costume, lighting, and sound create the effects the audience will see and hear onstage. Their responsibility is both artistic and practical. Their ideas must lie within the realms of possibility given the constraints of time and money. Often a director uses the same designer for set and costumes. When the two jobs are separate, both designers will discuss their ideas and develop a complimentary style. As a costume maker, a good relationship with the costume designer and understanding of her theatrical interests

Testing cloth onstage under the lights for a special effect. Photo: Hannah Bicât.

and visual vocabulary is vital. The degree to which you work together will depend on the number of workers in the costume department or 'wardrobe' as it is often called.

Lighting designers

If you miss the chance of blending the skill of the lighting designer with your own, you are chucking away the most powerful magic. They can change the colour and direction of light, and the colours and textures you use will be particularly affected by their work. Talk, exchange ideas, show samples of cloth and discuss with them the lighting for different scenes. Time will be short at the technical rehearsal so try to foresee possible special effects and any related hazards.

Stage managers

Stage managers can be the guardian angels or the deadly foes of the wardrobe. You should understand their job, and the amount of organization they must use to keep schedules and rehearsals running smoothly. It is to be hoped that they will understand your

Stage management and wardrobe finding space onstage for a quick change.
Photo: Hannah Bicât

difficulties too. Life will be sunnier for all concerned if the two departments work generously together.

The running of rehearsal and the stage is their responsibility and they have to perform the delicate task of making sure all departments get the time they need on the stage and with the actors. They will arrange the times of fittings, let you know who needs pockets and bags and what has to fit in them. They will time the quick changes and provide space for them close to the stage if necessary. They will arrange the costume parade and the time to rehearse changes or costume business before the technical rehearsal. Be clear about the information you need and as flexible as you can practically be about the timing of fittings. Some practice costumes are necessary for rehearsals. A mimed hat can vanish mid-speech, but a real one, even the wrong one, must be taken off, carried and put somewhere. You may be asked for practice costumes such as bags or long skirts for rehearsal. If so, try and bodge these together with good grace and as quickly as you can. The good will be returned when you are desperate for an extension lead or a glue gun.

Ask the stage manager to give you an update at the end of each working day about points that affect the costumes. It will save endless delays and frustration at the technical and dress rehearsals if pockets and costume props suit the purpose for which they will be used and actors know where they are going to put hat and gloves. Communication is the most important task in a production. The stage manager is the centre of a production and constant communication with him is vital.

Actors

The actors may be the last company members you meet, but they are as necessary to you as you are to them. Without them your cherished costumes are no more than a heap of rags.

Actors rehearsing with a half-made puppet. Photo: Hannah Bicât

Costume matters a great deal to most performers. It is a brave deed to walk on to a stage, and actors should be confident that the figure the audience sees reflects the character that the script, the director and they themselves have created. Nor should they have any worries about the practical elements of their costume. It takes a good relationship, established at unhurried fittings in a welcoming and interested wardrobe, to build this confidence.

Decision Making

If you think an actor is being too fussy about his costume, imagine the feeling of looking wrong in a room full of people who are all looking at you. Do, however, stick to your guns if you are still sure you are right.

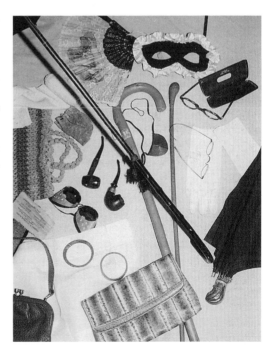

A collection of costume props.

27

THE WARDROBE OR COSTUME DEPARTMENT

A costume supervisor or wardrobe mistress, working closely with the designer, may organize the making, hiring and buying of costumes, shoes and wigs, supervise fittings and oversee the technical and dress rehearsals. Much of the work of costume making may be done by freelance workers in their own workshops and the supervisor will liaise with them, provide materials and information, and arrange the time and venue for their fittings with the actors and designer.

The wardrobe may have cutters, makers, dyers, armourers, wig-makers, milliners, jewellers, bootmakers, shoppers, sample collectors and other skilled workers, all of whom will be headed by the costume supervisor or wardrobe mistress. Most of the jobs in this list are self-explanatory – cutters prepare the patterns according to the designer's wishes, work out yardage and cut the cloth; dyers also break down costumes, which means making them look old, worn, bloody or wet.

In larger companies, dressers will help the actors get ready to go onstage and the wardrobe mistress may only be concerned with the day-to-day running of the show and not the making and fitting of costumes. The wardrobe department is responsible for the cleaning and repair of costumes during the run of a play. There should be a list on the company notice board where actors can note lost buttons and split seams for the wardrobe to repair. In a company where there are no dressers, there should be a laundry bag or basket where actors put washing that will be done by the wardrobe and replaced in the dressing rooms. Thought should be given about the facilities for washing, and more particularly, drying the costumes in time for the next show. Costumes should never leave the theatre during the run of the show without the wardrobe's knowledge in case they get lost or forgotten – or run over with the actor, and consequently unavailable for the understudy!

People who need this book are unlikely to have an armourer hammering away in the basement and are more likely to be working alone, responsible for all the jobs described above. Should this be the case, you and the designer must talk over the designs and the ideas behind them as much as you can and keep this communication going right through the rehearsal period. You must search for the cloth the designer has envisaged and make the shapes of the costumes as he has pictured them. You must find the boots and the hats and the gloves. You must see the characters as he does, so that at the final fitting he will see his pictures come alive. If you feel irritated when, after a long day's shopping for samples, nothing matches his imagined pictures, try to keep calm. It may mean that you haven't talked to each other enough about the designs. It may mean that it is just impossible to find the cloth or boots for the money available. Explain this and produce alternative suggestions and samples.

In a small company, you may well be both designer and maker and it will be your own pictures that you bring to life. You will be able to develop a close understanding of the way each particular actor uses costume to help the development of a role in the rehearsal period, and you need not be tied to re-creating a design that was conceived and drawn before the play was cast. The changes may be so slight as to be invisible to the audience and the director, but will make the actor feel as if he is wearing his own clothes and not a costume. Cutting, buying and fitting your own designs allows you to work closely with the actor and develop a costume together that suits the mind as well as the body. This means you have to exert iron self-control when shopping as it leaves you prey to a constant barrage of new ideas. Some

of these will be good and useful, but the danger of blurring your original design is ever present. That marvellous bargain of a length of blue satin might look glorious on the actor but upset the whole balance of the picture at the end of Act II. When tempted by colours and textures you long to use, remember the careful work on the script that led you to your designs in the first place.

THE FIRST PRODUCTION MEETING

There will have been previous discussions with the director and some of his key workers, and at the beginning of rehearsals there will be a full production meeting.

All the key workers in the company with the exception of the actors will be present. It is the time when directors can share their vision of the work with all the departments, and thoughts on the various aspects of the work can be aired. Sets, costumes, lighting, sound and all the practical and financial aspects of the show will be discussed. Everyone can see the costume designs and the set model. It is still a production meeting even if it is only 'two-in-the-kitchen' and the same questions have to be raised and answered.

This meeting may be your first opportunity to meet your fellow workers and learn how the director will rehearse the play. Some directors come to a production with a clear picture of the finished work, others will a less concrete idea through rehearsal. Their working patterns will affect yours. Your positive input at this time is essential to a successful working relationship; you have to keep the balance between unattainable visions and reality. If your background knowledge is secure, you will find it easier to be open-minded. You will need to listen and speak carefully to make sure you all understand each other clearly, and be sure to keep notes.

Write a list before the meeting of any points you want to raise, or questions you want to ask to clarify the production image in your mind and in the minds of your fellow workers. You might, for instance, want to know if the director envisages realistic wet rain for the storm, or a sound effect and a damp hat, or just meaningful acting. How much and how realistic should the blood be for the murder? (This is important, as you may need to have two costumes for matinée days so that there will be time to wash them – an extra expense on the budget.)

Set, costume, lighting, and sound must work together to create the visible fruit of the director's idea, and everyone involved will have made their own mental plan of the best way to achieve this. Good communication at this time is vital to ensure that everyone is working together. Note anything that occurs during the meeting that you feel needs further clarification with individual departments but need not concern the whole team.

RECOGNIZING LIMITATIONS

It is in the nature of theatre work for ideas to proliferate. Not all of these ideas will survive the journey from brain to stage. There are marvellous ideas that perhaps are unsuitable for the venue or the budget. It is quite usual for an idea to prove unworkable once rehearsals begin, either because of the actors or the time available. All creative people find this hard, and it takes much self-discipline and clear-sightedness to know when to let go and when to fight on. Often the idea has been worked on for a long time and it is disappointing and infuriating to throw it away, particularly if you feel you have not managed to convey your vision to your co-workers or infect them with your enthusiasm. Try to approach your own and other people's ideas with optimism, but if you have grave doubts you must speak out.

Explain your reasons and open the discussion to suggestions from the rest of the team. Theatre companies are as prone to clinging to the safety net of convention as the rest of the world. Sometimes a fresh approach can produce a solution that would not occur to someone with more experience.

Practical Optimism

A chilly, gloomy attitude can kill a young idea. Though you must keep a grip on the practical realities of production, be as positive, optimistic and generous with ideas as you can. Start with the assumption that most problems can be solved with a bit of juggling and imagination.

THE READ THROUGH OR FIRST COMPANY MEETING

This is the first time the director, the actors and the rest of the company meet together to work on the project. The director will give an outline of his plans. Music will be talked about and played. Movement, sound and lighting will be discussed. The set model will be shown, and its entrances, exits and scene changes demonstrated. The costume designs will be displayed and the play read by the cast. Someone from the wardrobe should take notes that apply to costumes during the read through and take a rough timing for quick changes. If the play is to be devised, an outline will be read and discussed and there may be a practical workshop.

Before this meeting, the costume maker has known the actors only as a list of measurements and perhaps a photograph. Now they are there in the flesh, and there is a chance to

Discussing costume props during a break in rehearsal. Photo: Hannah Bicât

see how they look, move and behave. Your observations at this time will help you gauge the right way to approach a fitting with each particular actor. They will be wondering whether their visits to the wardrobe will be an interesting pleasure or a battlefield. Most actors come to rehearsal with a bad costume experience in their past and a fear that this may be repeated. Your attitude at the first read through and the way you answer their questions will be the beginning of what should be a rewarding and creative partnership. Pay serious attention to any comments they have about the designs, as this will prepare you for possible pitfalls at later fittings. Listening to the actors' reactions to their costume design, and cutting your cloth accordingly, can forestall many problems with future fittings.

3 MANAGING THE BUDGET

If, by some unlikely chance, you have as much money as you need for a production, this chapter is not for you. If, on the other hand, you have ever read a script and despaired of clothing your actors, read on.

Allocating the Budget

However small the budget, you must know the precise sum so that you can allocate the money for the costumes in a practical manner. Vague phrases like 'spend as little as you can', are hopelessly imprecise and you should not agree to work without a clear financial plan unless you have lots of money yourself and are happy to risk it on the enterprise.

You must know how much money you have to spend. The person who is in charge of the budget may ask you to spend as little as you can – this is not good enough. You have to know the exact sum or you will not be able to use the funds wisely. Have a meeting at the beginning of the work and ascertain how you will reclaim any money you spend. It is usual to be given a float of cash to begin with and to claim more as this is used. You should try to get receipts for everything you buy. Car-boot and market traders are often loath to give them. If this happens, be sure to write down what you spent, when and where you spent it and what you bought. Have a special work purse or pocket where you put all receipts. Update your accounts regularly to avoid the horrible realization that you are a costume short, have a jacket that needs dry-cleaning and no money left in the pot. It is your responsibility to make sure this does not happen.

It is a good idea to keep quite a large proportion of the money in reserve for the technical and dress rehearsals. On a small budget this could be as much as a third, and on a more generous one, enough to dress one actor. This may seem a waste of valuable resources but in most theatre situations, the lights, set and costume are not seen together until the performance looms very near. Should a change of design or character arise at the last moment, it will be much better for the play and the confidence of the company if you can say yes rather than no. There are also minor, last-minute crises, which you will have to cope with in a hurry. False nails and cufflinks can guzzle a tiny budget and you will be so rushed by this time, and have so much to do, that you will not have time to shop carefully. You cannot waste time economizing when you are dashing round the shops trying to buy innersoles and hair grips before the curtain goes up on Act II. You will have no trouble spending the spare

budget on small, last-minute improvements if there is money in the pot at the end of the final dress rehearsal.

GATHERING SUPPLIES

Hoarding

It is essential to have somewhere dry to store your supplies and it can never be big enough for all the things you will want to keep. The size of your collection will depend more upon the amount of storage space available than the money you have to spend. Try and keep separate, labelled boxes for haberdashery, tools, patterns, cloth and accessories. It is useful to have hanging rails for clothes but dustbin bags will do at a pinch. Be sure to label them boldly. Many a weeping wardrobe worker has been found rummaging through the dustbins having thrown a bag of costumes out with the rubbish. As your collection grows, lack of space will force you to be more selective. Experience will teach you which things are rare and which ubiquitous.

If space is a dreadful problem, it is wiser to hoard haberdashery, patterns and tools. They take less room, will not be attacked by moths and you will need them for every job.

After the chaos of each production, clean and mend used costumes. Re-hang the clothes, sort the haberdashery and prepare for the chaos of the next. Most clothes can be washed with care. The exceptions are items such as jackets, which have linings or internal stiffening. Because these may shrink in differing ratios, washing will often be the ruination of the garment and you must resort to dry-cleaning. Make absolutely sure that everything you put in plastic bags is bone dry. The smell of mildew that will arise from damp storage is deeply depressing and hard to eradicate.

Costume workers become as obsessed with their storeroom as gardeners do with their compost heaps. It will feed your work and stop

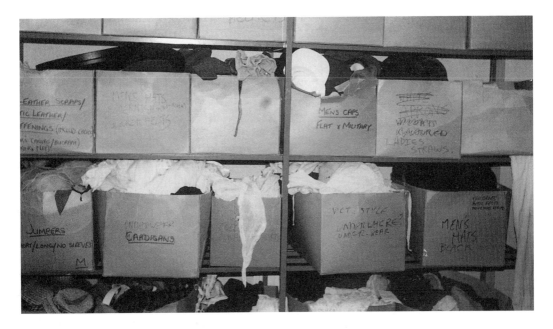

Labelled boxes for hats and accessories stored on industrial shelving.

the realization of your imagined world being starved by lack of money. It will give you ideas and help you to make them come true.

Begging, borrowing and scavenging

Never walk past a rubbish skip or a heap outside the back door of a shop without having a look. There may not be cloth, but there is often rope, sacking, packaging, polystyrene, polythene, cardboard and paper. As well as being a source of free practical supplies, rubbish jogs your imagination. It is a triumphant pleasure to look in a skip and see the crowns, monsters and post-modern corsets that disguise themselves as urban rubbish. The most rewarding skips and rubbish will be found outside offices and shops in smart areas. As your scavenging experiences open your visual imagination, you will find it difficult to walk anywhere without being beset by pictures and possibilities.

Useful rubbish collected for a project.

> ### Practical Creativity
>
> Try not to let the excitement of scavenging and the thrill of the chase blind you to your responsibilities to the script, the director's vision and the brave actors who must wear and believe in your creations.

Actors are your most valuable source of free costumes. It is of desperate importance to them to have a costume in which they feel comfortable and confident. Most actors working on a low-budget show will agree to wear their own shoes and clothes. You must remember that they are not obliged to do this, and if someone has to roll about on the floor and die in a pool of blood it is better that the costume should be bought by the wardrobe. Be careful not to abuse the actors' generosity: their budget is probably as tight as yours.

Make sure you see the borrowed costumes along with the ones you have bought or made, and that any borrowed items are under your care well before they are needed. The actor's description cannot give you an accurate picture: you must see it with your own eyes. Write a list of all borrowed costumes, check with the stage manager or in rehearsal that nothing in the action is likely to damage them, and make sure they are returned at the end of the run.

Most households have junk they cannot bear to throw away. It is much easier for them to give it away for a purpose, and what better purpose than the costume store? As soon as people know you are collecting, they will give you bits and pieces to add to the pile. Accept everything and weed out later. If you work in, or have connections with, any sort of institution, use their notice boards. A request

for old curtains, broken beads, dress patterns or men's boots can produce a startling Aladdin's cave of treasure. Remember to credit these kind people in the programme when appropriate.

Large department stores will sometimes give you cloth from old window displays, defunct school uniforms and, if you are really lucky, last year's flash-in-the-pan fashions – or at least sell them to you very cheaply. Always offer a programme credit and free tickets, if the management allows it, in gratitude for the time and help given to you.

Shopping

Shopping is a mundane word for this skilled and most creative activity. You are gathering the supplies that will transform the drawings in the designs and the pictures in your mind into reality. You can, of course, buy from specialist shops – bootmakers, milliners, fabric printers and highly skilled costume makers. However, you are probably not in that position if you are reading this book. You are more likely to be strapped for cash, and short of skilled helpers. The same basic rules apply however much or little you have to spend. If you have plenty of practice shopping within a tight budget, you will have no trouble expanding your horizons when you are given the chance.

The best and cheapest suppliers are charity shops, jumble sales and car-boot sales. They are a treasure chest for the impoverished costume maker.

Charity shops are the most expensive and it seems wrong to haggle over the prices when your money is supporting good causes. You can always try for a cheaper price at a car-boot sale, as no trader wants to have to take his stock home at the end of the day. The cheapest of all is the last hour of a jumble sale, where you may well be allowed to fill a dustbin bag with clothes for a pound. Be bold, polite and

A hoard of beads and bangles in the wardrobe.

friendly. Take a big rucksack, a tape measure, an open mind, comfortable shoes, a sense of humour and lots of change. Know what you are looking for and resist the temptation to buy wonderful things that will not fit the cast.

Imagine you are shopping for *Abigail's Party*, a play by Mike Leigh set in the late seventies. You will know the colour and style of the set. You will have researched the period and will have firmly in your mind the characters that you must dress and the sizes of the actors who will play them. You will also have asked them if they have anything of their own that might be useful, seen it and listed it.

35

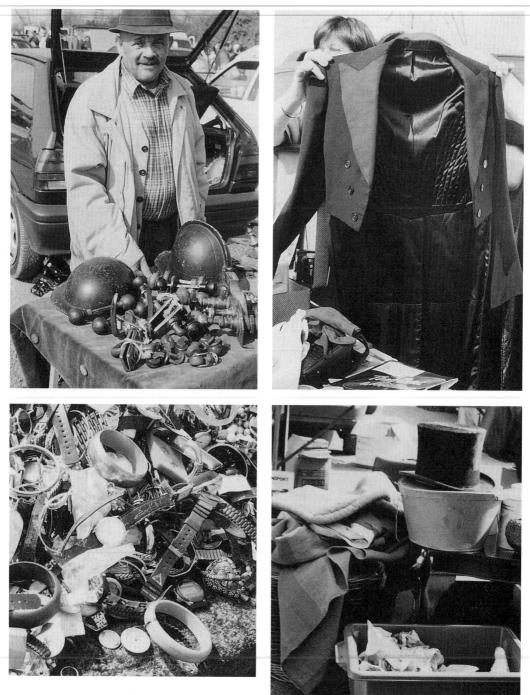

Treasure for the seeker at a car-boot sale.

It is useful to have a list set out something like this, which you have made from your costume plot.

Beverly: dress, shoes, jewellery
Angela: dress, shoes, coat, handbag, own necklace and ear-rings (pink)
Susan: dress, coat, own bag (beige), and jewellery
Laurence: suit, tie, own shirt (blue or green), cuff-links, own shoes, own socks
Tony: suit, tie, own shoes, own socks

As you look round the stalls or through the racks, try not to be distracted by items you do not need for the play. You must keep the feeling, colours and textures clear in your head or the audience will receive conflicting messages.

Never skip the preparation. Your concentration and your certainty of the styles of the period, the actors' measurements and your knowledge of the characters are vital when you are shopping if you are not to waste time and money.

The first purchase is usually the most difficult and should be one of the larger items such as a dress or a suit. This will set the tone for the other clothes. As you buy more, the picture the audience will see starts to grow in your mind's eye. Work towards the smaller items such as shoes or jewellery. The audience will see less of them but they may not use less of your money. They will, however, make a considerable difference both in setting the play in its period and making the actor feel complete and confident.

It is unlikely, though possible, that you will find genuine seventies clothes, but if you have studied the fashions of the time thoroughly before you shop, you will be able to compromise and still be convincing. You will see how to alter a dress or trousers to make them suit your purpose. There is more help on how to use modern clothes for period plays in Chapter 9.

Shopping in this way requires great concentration. You are designing the play around the things you find and you must remember all the time the demands of script, director and budget. It is easy to let excitement or despair overrule all three. You must remember the actors, who can only do their best work if their costume feels right. Above all you must visualize the pictures the audience will see.

At the end of each shopping session, spread out your purchases in their character groups, check how everything looks together and what is lacking. Tick off your list. As the list gets shorter you will be looking for more precise items. Perhaps you will need orange ear-rings to go with Beverly's dress, or maybe yellow shoes would display Angela's uncertain taste and make her dress look even more aptly unfortunate. Make a new list for the next day's shopping.

Markets are an excellent source of costumes and cloth. You can wander round without

Costumes adapted from modern clothes for a play set in the 1920s.

feeling obliged to buy, and the prices are always cheaper than the shops. Visit any markets you can find where the ethnic population is varied, as you are likely to find a wider range of cloth, cut, and colour. Sales can be useful, particularly if you need a matching set of clothes for a basic costume. Shops will sometimes give you a reduction for quantity if you offer them a credit in the programme.

Keep a constant lookout for haberdashery. Thread, tape, elastic and fastenings can eat up a small budget with frightening rapidity. It is often possible to buy whole reels in markets or car-boot sales costing a fraction of the shop price and you should develop as big a stock as you can. Do not, however, be tempted by cheap thread unless you can be sure of its quality. It will drive you mad. Sewing machines will tangle and crutch seams will split. Buy the best you can afford. Costumes are useless if they are not strong enough and no actor or actress should be obliged to swordfight in unsafe trousers, or make love in an insecure bodice.

Boots and shoes are a severe challenge to the tight budget. Nobody who has had a blister can fail to appreciate that an actor cannot give his best performance with painful feet. If he offers to wear his own shoes and you can possibly make them look right, accept the offer and do your best. If you have to buy shoes without a fitting, arrange to be able to change them if necessary. You can paint, dye, decorate, alter and mend to make them look suitable, but they must feel right as they will affect the way a performer moves and feels.

Study the design, whether your own or someone else's, before you set out. Work out how much cloth you must buy and what you will need in the way of trimmings, linings, stiffening and other extras. If the actors have already been cast, you should find out their measurements. Even a rough estimate of height and build is helpful when estimating yardage.

Carry a small sample of any cloth you have in stock that you think might be appropriate, so that you can compare it with other fabrics before you buy. As you look round the shop and begin to find possibilities, unroll a metre of cloth and see how it hangs. Is it the right weight for the purpose? Is it strong enough? Can you afford it? Will it be too shiny? Too textured? Will it look right with the other costumes onstage? You must imagine it in the stage light. This takes practice and until you are experienced, carry a small, bright torch in your pocket. This will give you an idea of how the textures and colour will react to the light. You can use the same trick with an ultraviolet torch to see which cloths react to the light and which remain dim. If you can engineer an opportunity to look round a fabric store with someone who knows about lighting, grab it. You will learn more in an hour of their company than you can imagine. You must be able to visualize what the light will do to the cloth, as no audience will see it without the stage lights.

WORKING FROM A DESIGN

The designer can draw and paint the embroidered front of an eighteenth-century waistcoat. A few more brushstrokes create the braid, buttons, buttonholes and pockets that give it richness and character. The image of the finished garment, with its attendant coat and ruffles, is clear and glowing in his mind's eye.

The maker has to view this picture with a practical eye. How much cloth will it take to make? How many buttons? Which parts will need to be stiffened? Will the pockets be used, or can they be decorative flaps? Will the audience see the back and the lining? Will the audience see the actor unbuttoning? If so, the buttonholes must be practical and not just for show. How near is the audience? If very near,

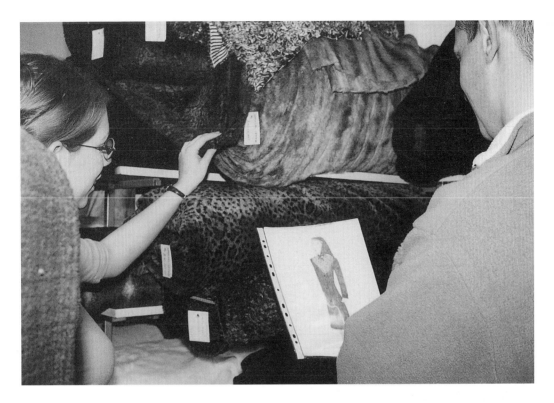

Student designer and fabric shop owner discussing the relative merits of fur fabrics using the design for reference.

the embroidery must look convincing. How far from the stage is the back row? They must be able to see the waistcoat is embroidered. How should you cut the sides so that the actor can draw his sword or pull the phial of poison from his pocket without fumbling? And, ever lurking, the cost, in time as well as money. Embroidered fabric of a suitable design may not be available or affordable. You could, perhaps, paint or appliqué the fabric; use a printed cloth and enhance it with paint; or stencil it. Work out possible solutions and discuss them with the designer. Keep the designs clean in plastic folders and slip into each folder a list of the separate items you must provide.

The notes for the design for Artemesia on page 40 would be something like this:

- Undershift: 5.5m thickish muslin
- Overdress: 5m heavier cloth (perhaps use the yellow velvet curtains already in stock)
- Apron: 2m calico
- Headshawl: approx. 1m square of patterned fabric or a ready-made shawl
- Stockings: dye
- Cord for lacing
- Eyelets for lacing
- Bias binding for neck and ties of underdress
- Stiffening for bodice: 1m
- Boning for bodice: 5m boning or 2×20cm, 2×25cm, 4×15cm bones

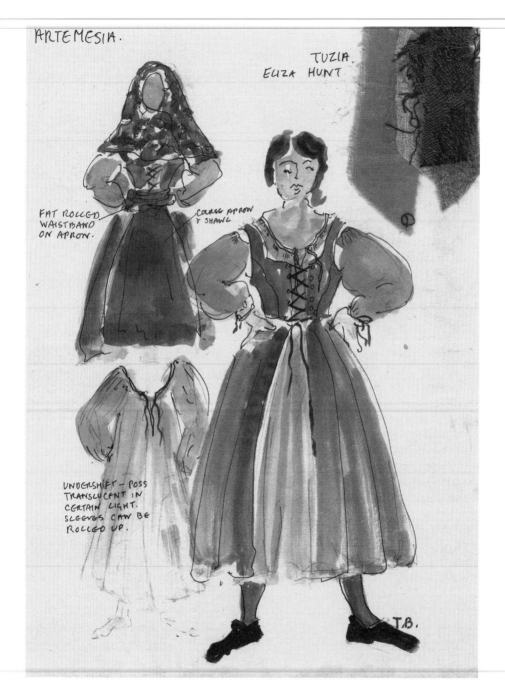

Costume design from which the maker must compile a shopping list of fabric and haberdashery.

Shopping for a costume that has already been designed needs a different technique. You should have talked to the designer and developed a working vocabulary that you both understand. You should, if possible, have made yourself familiar with the style of his previous work. Look through the designs with him and discuss every detail. Ask about anything that is not made clear in the drawing. Make sure you know how he would like the costume to be cut, as the placing of the seams will affect the amount of cloth you must buy. What will the costume look like from behind? What textures and drape of the cloth does he envisage? Find out what he likes in the way of buttons, linings and trimmings. If it is possible, take him with you when you shop, otherwise collect a sample of any cloth you feel is apt and take it back for discussion. Sometimes, however, the designer is not available and you must take these decisions yourself.

You may find one cloth which, though expensive, is so perfect that you are prepared to economize on other items. Think it through, and make sure that the audience will see the same quality onstage as you do in the shop. You may find the perfect texture but the wrong colour. Could you dye it? Any cloth that is pure silk, wool, linen, viscose or cotton will take dye easily, but you must consider the effect of the original colour on the new one. It is often possible to line a light fabric with a cloth, which doesn't look good, but will give the top fabric a better hang. Cut a small sample of everything you buy for your folder so that you have an easily accessible reference ready for the next shopping expedition.

When you find a shop with a stock and atmosphere that suits you, try to use it regularly. Get to know the people who work there. Don't feel shy about showing them your designs and asking their advice. If it is a good shop, they will know their stock. They may not have had experience of costuming as opposed

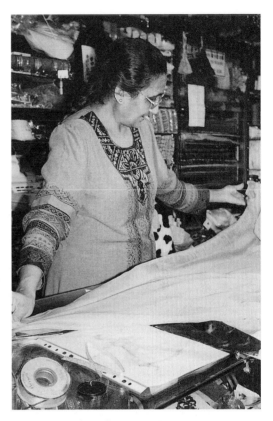

Using the design to benefit from an expert's knowledge of silk in a shop crammed with colour.

to dressmaking, but they will know about cloth. If you are lucky, they will have a store of unsuccessful or faulty lines, many of which you may be able to use. Faulty cloth is sold at greatly reduced prices.

It takes some time to learn which faults in the cloth will show onstage. Look at an unrolled section of the cloth from the same distance as the front row of the audience. Think of the design. Will the cloth be flat or heavily gathered? If the light shines through it, faults will be more likely to be visible to the audience. A gathered or pleated design hides

41

faults in the weaving. Cheap cloth often fades where it has been exposed to the light during storage and the colour may be patchy. This may not matter to you, as you may want the finished garment to look old. An actor may have to appear in a black cloak in a dark scene. A cloak uses many expensive yards and if you skimp on the quantity of cloth, its silhouette and hang can never look right. But even serious faults in the cloth will be concealed in the moody lighting.

When you are choosing patterned cloth, think of the distance from which the audience will see it. Look at it through half-closed eyes and from as far away as you can. A pattern with delicate colour contrasts may blur into a single colour from halfway back in the stalls. Contrasts in texture, such as a shiny flower on a matt background, tend to carry well as the stage lighting accentuates the contrast.

Follow the same system with items such as buttons and lace. It is easy to forget how the audience will read them. Delicate lace may look lovely in close up, but you might be able to achieve the same effect at a fraction of the cost with net, muslin or even a stencil. The effect that will be seen is the edge of the lace against the skin or cloth. For buttons to be noticed, they must contrast with the garment or stand out enough to create a shadow when lit. A great deal of time and money can be spent on details that will only be seen by other actors – most situations do not require this degree of realism.

All this can be very disheartening. There are dreadful, miserable days when nothing looks right and if it does it is too expensive, and your feet are cold and wet. Try not to be downcast. There are also wonderful and exciting days when the whole play jumps into your haversack for a fiver! You will find the right thing in the end or if not, will be able to change your focus slightly and start again. Keep thinking about the characters for whom you are buying and what the audience will see.

The effects of different lace against a contrasting background.

This advice can only point the way. Every job presents a new set of problems. Reading is no substitute for the real thing and if you read this chapter before your first job, and re-read it afterwards it will make a different sort of sense. If you read it again when you have been costuming plays for a few years, you will find it hard to believe there was ever a time when you could not think how to start. You can train your eye to search shops selectively by forcing yourself to look only for the scarlet things (easy), then the dark green things (more difficult), and then things the exact colour of a ripe conker or your fingernail (most difficult). You can make your eyes notice only the particular gleam of silk-satin or the rich density of pure cotton velvet and ignore other textures. You can learn to tell a shoe size at a glance, or spot from twenty feet away a bias-cut thirties dress hanging out of a stall holder's heap. Experience, the wish and need to find just the right thing and the excitement of the job will teach you.

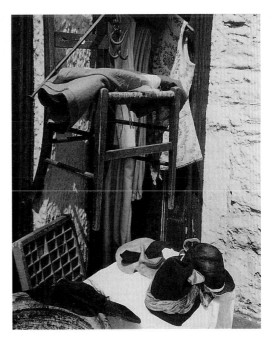

Costumes amid other bric-a-brac outside an antique shop.

4 BASIC SEWING SKILLS AND SHORTCUTS

This book assumes you have some basic sewing skills and can use a sewing machine. If this is not so, you should find a book, or better still a person, to show you the first stages of sewing. Learn how to thread up a sewing machine and to sew forwards and backwards, to sew a straight line, an accurate curve and a simple zigzag edge.

You should be able to sew seams and hems, stitch darts, sew on press-studs, hooks and eyes, and buttons, and know how to gather fabric by machine or by hand. It is useful to know how to follow the instructions to make a simple garment from a paper pattern, but you should be able to bodge your way through this chapter with only the most basic skills. If you have done quite a lot of sewing, skim through and pick out the tips and shortcuts you will find useful for costume making. If you have less experience, work through Chapters 4 and 5 thoroughly to consolidate your technical skills. The methods are all quick and easy to follow, so even a beginner may start making costumes immediately.

As you become more experienced, you will want to achieve a better finish and more historically correct cutting skills. Instructions for more conventional sewing methods may be found in any dressmaking handbook, and some of the many useful and exciting books on cutting period costumes are listed in the Bibliography.

EXPLANATION OF TERMS

You will need to digest the information that follows before you begin to work through this section of the book.

It looks like a long list but you will probably find that you know most of it.

- **Gather:** to draw the fabric up with a thread.
- **Notch:** a small cut in the fabric, placed to help with matching pattern pieces when sewing.
- **Nap:** if you stroke some types of cloth downwards, the surface of the cloth feels smooth. If you stroke it upwards, it feels rough. This is because of the nap and it affects the way the light strikes the fabric. To appear the same colour in the light, the pattern pieces have to be cut so that the nap goes in the same direction on all of them. Experiment with a piece of velvet and you will quickly understand how this works.
- **Seam allowance:** the cloth between the stitching and the rough edge of the fabric.
- **Tacking:** an easily removable large stitch used to hold seams together accurately for fitting or final stitching. You can use the longest stitch on the sewing machine for this if the seam is not complicated.
- **Right side of fabric:** the side of the cloth that shows on the finished garment.

- **Wrong side of fabric:** the inside of the fabric on the finished garment.
- **Raw edge of fabric:** the unfinished cut edge.
- **Selvedge:** the edge of the fabric finished in the weaving process. It runs down the edge of the length of the cloth.
- **Straight grain:** the up and down direction of the cloth more or less parallel to the selvedge.
- **Bias: the diagonal cut of a fabric** (as if from corner to corner of a square).
- **Circumference of a circle:** the distance round the outer rim of a circle.
- **Radius of a circle:** the distance from the centre point of a circle to the outside edge.
- **Facing:** a piece of fabric cut to the same shape as the raw edge of a garment, such as a neckline, and used to finish off the edge.
- **Binding:** a narrow strip of cloth or tape, folded and stitched over the raw edge of a garment. Binding can be cut on the bias to bend round curves.

Exercise 1: Machine lines

There are many places where mistakes will not show on theatre costumes. A wobbly seam or hem is not one of them. Draw some lines, both straight and curved, on a piece of cloth and practise until you can machine along them accurately.

Most sewing machines have lines etched on their bed to the right of the needle. Aligning the edge of the fabric with one of these when you are sewing a seam will help you keep straight. Look at the line and the edge of the cloth, not the needle. Guide the cloth gently in the right direction. Relax your shoulders. If you need an extra-wide guideline for a particular purpose, stick a strip of masking tape or a sticky label on to the machine bed to guide you.

Know Your Machine

Read the instruction book for your machine, which will contain a great deal of helpful advice. Some machines have attachments for particular tasks such as buttonholes, gathering and hemming, which most people do not use because they have not got round to reading the instructions. However, these handy gadgets have been invented to save people like you time and tedium.

Exercise 2: Ironing, pressing, trimming and clipping

When you are efficient with the iron, it will take the place of tacking and pinning and make your work neat and more accurate with very little effort. You will need, as well as the iron, a spray bottle of water for damping the fabric and a thin cotton cloth, preferably thin enough to see through a little. When working on wool or fabric that marks easily, use this damp cloth to press through. Press every seam open or flat before you sew the next one. Press velvet upside-down on a piece of spare velvet laid right side up on the ironing board. If the iron still makes marks, hang the cloth in a steamy bathroom.

Ironing straight seams
Take a piece of cloth about 18in (46cm) square.

1. Cut it in half.
2. Seam it together again with right sides together.
3. On the wrong side, press the seam open.
4. Turn the work over and press on the right side. Use steam or spray to make it lie flat.
5. Cut it in half again across the seam.

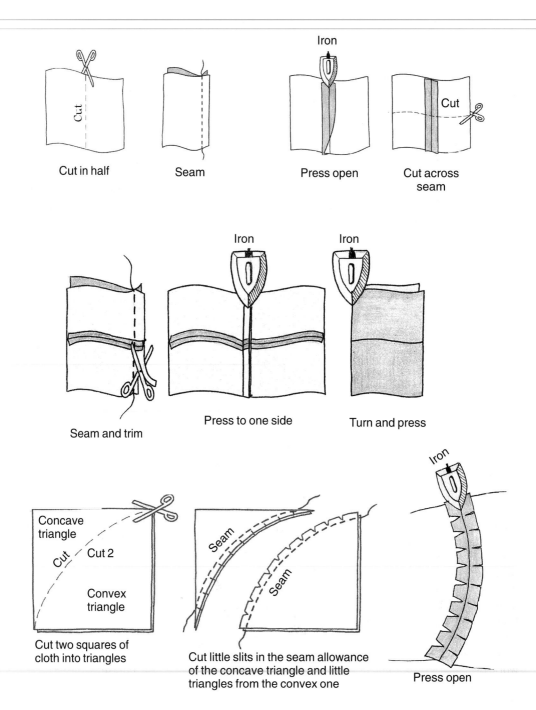

Iron

Cut in half

Seam

Press open

Cut across seam

Iron

Iron

Seam and trim

Press to one side

Turn and press

Concave triangle

Cut

Cut 2

Convex triangle

Seam

Seam

Iron

Cut two squares of cloth into triangles

Cut little slits in the seam allowance of the concave triangle and little triangles from the convex one

Press open

Ironing seams.

6. Seam it together again and trim the seam allowance to $\frac{1}{4}$in (0.5cm).

7. On the wrong side, press the seam. You will find it difficult to press such a small seam open, so press both seam allowances to the same side. Be very careful to keep the seam flat. It will want to create a fold over the stitching line.

8. Steam press it when you have checked on the right side that you have made a neat, straight line.

9. Fold the cloth over. enclosing the seam and press so that the stitching line is on the edge of the fold. You will use this pressing technique when you are sewing French seams and facings. You may have to roll the cloth between your fingers to get the line on the very edge.

Ironing curved seams

Take two pieces of cloth 18in (46cm) square. Lay them on top of each other and cut them diagonally on a simple curved line. This will leave you with four triangles – two with a concave, or inward curved side, and two with a convex or outward curved side.

1. Stitch the concave pieces together with a narrow $\frac{3}{8}$in (1cm) seam.

2. Cut little slits in the seam allowance from the edge to the stitching about every 3in (8cm). This allows the cloth to spread out round the curve when you press it open.

3. Iron the seam open on the wrong side using the point of the iron to separate the seam. If it will not lie smoothly, cut more slits closer together.

4. Press on the right side. This can be quite a fiddle on a tight curve and you may have to hook it over the end of the ironing board or work over a fat wad of cloth held in your hand so that you can drape the cloth over it. However, you can usually manage on the point of the ironing board.

5. Stitch the outward curved pieces with a narrow $\frac{3}{8}$in (1cm) seam.

6. Cut little triangles out of the seam allowance. This will stop it bunching up and looking lumpy when you turn and press it. Cut more triangles if it does.

7. Press open as before.

By this time you will have realized that there are two separate actions. One uses the point of the iron for fiddling about and the other uses the whole base of the iron for pressing flat. Using the iron like this is a particular skill and not the same as ironing any old shirt. It is a time-saving aid to accuracy and a good finish, worth mastering as a separate skill. It can make quite a rough bit of work look infinitely better and good work utterly professional.

Exercise 3: Useful seams

Start and finish each seam by machining backwards and forwards for three or four stitches to secure the thread into the fabric unless you want it to pull out easily.

Straight seam

1. Place the two pieces to be joined on top of each other with right sides of the cloth together.

2. Stitch with a straight stitch about $\frac{1}{2}$in (1cm) from the edge.

3. Open the cloth out and press the seam open using the point of the iron to separate the cloth and make it behave.

Stretch seam

For stretchy materials use the method above with a small zigzag instead of a straight stitch unless you have a special stitch on your machine for stretch fabrics. If you use an ordinary straight stitch on stretchy material, the thread will snap when the garment is worn. Be wary when pressing stretch fabric – always experiment on a spare scrap.

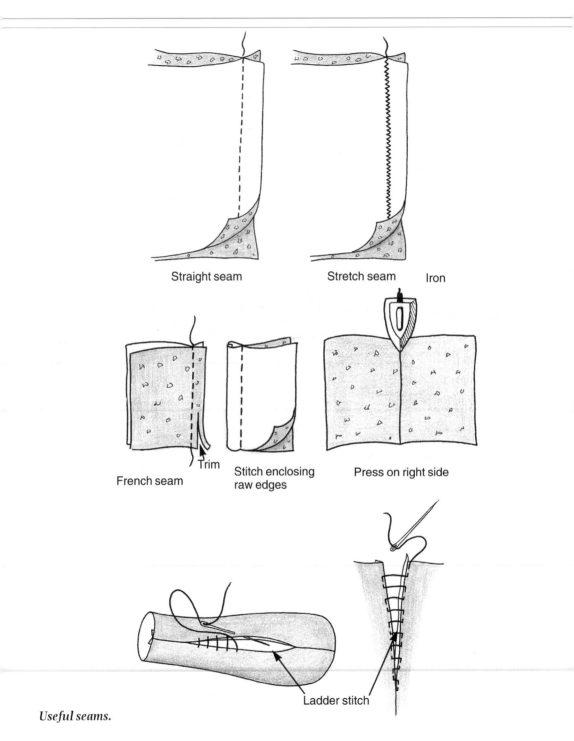

Straight seam

Stretch seam Iron

French seam Trim

Stitch enclosing
raw edges

Press on right side

Ladder stitch

Useful seams.

French seam
1. Sew the seam with the wrong sides of the cloth together.
2. Trim the cloth very close to the stitching. Turn the work so that the right sides of the cloth are together and press flat, so that the stitch line is at the edge of the cloth and the raw edges are enclosed.
3. Stitch another line $\frac{1}{4}$in (0.5cm) to hide the raw edges inside the seam. There should be no raw edge visible on the right side of the fabric.

Only use this method on straight seams. It is a useful seam if the material frays a lot or where the seam needs to look neat on both sides – on a rolled-up cuff, for example. French seams can also be useful when you have mistakenly sewn the work inside out as it reverses that process, though it will make the work a little bit smaller.

Corner seam
Imagine you are sewing the corner of a pillowcase. Always turn a sharp corner with the needle in the cloth.

1. Mark the corner where you are going to turn the stitching with a dot.
2. Machine to the dot, stop with the needle in the cloth, raise the machine foot, turn the cloth using the needle as a pivot, drop the foot and continue the line of stitching.
3. Before you turn and press it, trim the seam allowance across the point to reduce bulk.

Ladder-Stitched seam
This is a hand-stitched seam. It can be most useful as it makes a neat, turned seam but you work from the right side of the cloth.

1. Machine a tube of cloth to fit round a paperback. Leave a gap of about 3in (8cm) in the middle of the stitching.
2. Iron the seam open.

3. Turn the tube right side out and slip it over the book.
4. Use strong thread fastened securely to one end of the split with a knot and a couple of small stitches. Take a stitch in and out on the right side of the split on the seam line and then on the left, working along the seam line at staggered intervals. It should look like a ladder of horizontal bars. What you are actually doing is making a running stitch from the outside rather than the inside of the cloth.
5. When you get to the end of the split, pull the thread firmly and all the raw edges will tuck themselves neatly inside. Finish off securely with three or four little over-lapping stitches.

It may sound complicated to read about but it is easy to do, wonderfully useful and well worth learning. You can use it in emergencies while an actor is wearing the costume and his shoulder seam splits just before his cue, and in other less desperate situations, such as hat or padding making when it is impractical to work inside out but you need a neat finish.

Exercise 4: Binding and facing.
Binding is a narrow strip of matching or contrasting fabric that is sewn folded over the raw edge of cloth to finish it and stop it fraying. It can be decorative or invisible. It can add strength to the edges of cloth, decorate an edge with a line of contrasting colour or texture, or be a subtle, light and invisible finish. It often provides a useful channel to thread with wire, elastic or tape. When dressmaking you would usually hem the binding with invisible hand stitches on the wrong side of the garment. When you are working on a costume, you can hem it by machine on the right side. The audience will not notice as long as you use matching thread, and it will be strong and very much quicker.

Working with bias binding

Binding made from fabric cut on the bias, or crosswise grain of the fabric, is called bias binding. It stretches and bends. Consequently, it is most useful for finishing off curved hems, braiding round hats and decorating curves. You can cut your own in any fabric you like. There is a useful little gadget you can buy in good haberdashers which makes it easy to turn the edges with perfect regularity. You can also buy ready-made bias binding in many colours and widths. It comes in a cotton or satin finish. If you see an odd roll being sold off cheaply, buy it for your store cupboard – it is bound to be useful whatever the colour. The most useful width of bias binding for theatrical purposes is about $\frac{3}{4}$in (2cm) wide. When you buy it, both raw edges will have been turned in along the length and pressed with a crease. This acts as a guideline when you are sewing. Try this exercise with ready-made bias binding to see how it works.

1. Take a piece of cloth about 12in (30cm) square and cut a curved section off one corner.
2. Take a strip of bias binding about 1$\frac{1}{4}$in (3cm) longer than the curve you have cut.
3. Unfold one edge of the binding.
4. Align the raw edge of the binding with the curved raw edge of the cloth, with the right side of the binding against the wrong side of the fabric.
5. Sew them together along the fold line of the binding which will be about $\frac{1}{4}$in (0.5cm) from the edge.
6. Fold the binding over the raw edge so that you can see the same amount on the wrong and right side of the fabric. The raw edge should be sandwiched inside the binding. Iron carefully to make the binding lie smoothly and stitch it in place on the right side.
7. Bind an inward-curved edge in the same

way. This will require more work with the iron before and after stitching to make it behave as you want.

8. Later, with practice, you will be able to fold the binding over the edge and stitch it all on at the same time from the right side of the cloth.

To use bias binding as a facing

You can make the facing show on the right side of the fabric or conceal it completely on the wrong side according to your design. It is more difficult to get wide bias binding to lie flat as a facing, so buy and use the narrow width for this until you have had some practice.

1. Take a piece of cloth about 12in (30cm) square and cut a curved section off one corner.
2. Take a strip of bias binding about 1$\frac{1}{4}$in (3cm) longer than the curve you have cut.
3. Unfold one edge of the binding.
4. Align the raw edge of the binding with the curved raw edge of the cloth. The right side of the binding should be against the right side of the fabric.
5. Sew them together along the fold line of the binding which will be about $\frac{1}{4}$in (0.5cm) from the edge.
6. Cut little triangles out of the seam allowance to avoid bulk when finished.
7. Fold the binding right over the edge so that the stitching line is on the finished edge and the binding can be seen only on the wrong side of the cloth. Press carefully. You may need quite a lot of steam or spray to make it lie flat.
8. Machine it down as close as you can to the unstitched edge of the binding. It often helps to flatten the binding if you machine a line $\frac{1}{8}$in (0.25cm) from the finished edge first.
9. Reverse the cloth to make the facing show on the right side as a decoration.

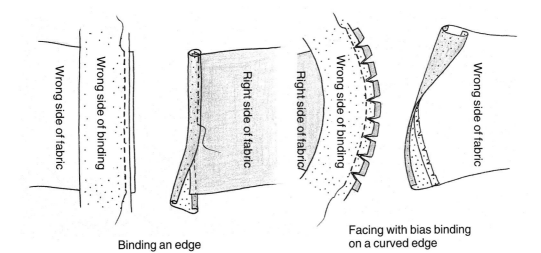

Wrong side of fabric

Wrong side of binding

Right side of fabric

Right side of fabric

Right side of binding

Wrong side of binding

Wrong side of fabric

Binding an edge

**Facing with bias binding
on a curved edge**

Right side of cloth

Wrong side of cloth

Shaped facing cut to echo
the neck

Facing turned and pressed
to inside of garment

Attached at neck
edge right sides together
and clipped

Bias binding as a facing.

51

Once you have understood how binding works, you will see how you can vary its width and visibility. Cut the binding 1¼in (3cm) too long so that you can fold in a little hem to neaten each end.

Shaped facing

You can also finish a curved edge, such as a neckline, with facing. You cut this from fabric to echo the shape of the curve and about 2½in (6cm) deep. The facing is attached right sides together to the neckline, clipped, turned to the inside and pressed flat. It can be stitched on to the inside of the neckline to stop it flapping out by mistake. Have a look at the facings on blouse or dress necklines, or a paper pattern to see how they work.

Working with straight binding

Straight binding is used in the same way as bias but is slightly easier to turn and press. You can use ribbon or tape to bind straight edges and avoid having to turn them.

Exercise 5: Finishing hems and edges by machine

You can use the edges of the pieces of cloth from previous exercises to try these finishes.

1. Zigzag on a single edge – the right-hand swing of the needle should just clear the edge of the cloth and on the left swing, the needle should stick in the cloth. Experiment on various types of cloth to find the best looking length and width of stitch for different textures of cloth. If it looks messy and frayed try the next technique.
2. Zigzag on a turned edge – turn the edge of the cloth a tiny bit, press if it is not too narrow to manage, and sew so that the width of the stitch covers the rough edge. When you get good at this you may find you can do it very quickly by curling the cloth through your fingers in front of the machine foot as you zigzag stitch.
3. Zigzag on a single edge (*see* 1 above) – turn over a single hem, press thoroughly and

Finishing hems and edges.

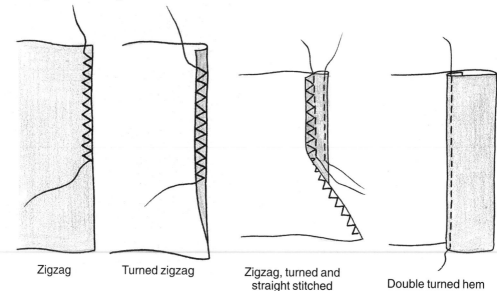

Zigzag Turned zigzag Zigzag, turned and straight stitched Double turned hem

straight stitch. The width of the turn will depend on the type of cloth and garment. Consider the way it will look best from the audience. A curved hem will need a smaller turn and more careful pressing than a straight one. It is sometimes improved after pressing by an extra row of stitching very close to the fold.

4. The usual double-turned hems sewn by machine or hand

Stitching Straight

When you use a zigzag stitch you will find it hard to keep straight if you watch the swinging needle. Choose an appropriate guideline on the machine bed, align the edge of the cloth to it and concentrate on keeping the cloth to the mark whilst you sew. If the guidelines are too far away for a zigzag edging, line up the edge of the cloth with a part of the machine foot. To sew a line further in from the edge you can use sticky paper or tape stuck on the bed of the machine as an extra guideline.

Waists

The same techniques may be used for items such as cuffs, kneebands and caps where cloth needs to be drawn in to fit a body.

The most common waistband is like a binding on a garment that can be fastened to fit round the waist. You see it on the top of jeans and on some trousers and skirts in a quite structured form. It is often stiffened with interlining. However, it can be soft and threaded with elastic, which is a useful way of making a gathered skirt adjustable without being bulky. There are many other ways of finishing a garment at the waist. Here are a few useful ones for costumes.

1. For a straight cut garment. Good for trousers or skirts, which are not very full and for close-fitting stretchy garments such as tights. Make a hem at waist level. Fasten a safety pin to a length of elastic or drawstring, and thread it through. This may be quick and easy but it is often bulky, unflattering and clumsy, and should be used with caution. It cannot be used if the waist of the garment is cut in a curve unless the cloth is very stretchy. It looks better if you machine a line $\frac{1}{8}$in (0.25cm) from the finished top edge so that the channel for the elastic is more defined.

2. For a curved or straight edge that needs to be drawn in. Zigzag the waist edge so that it will not fray and mark it into quarters. Cut a length of elastic to fit the actor. Mark that into quarters. Pin the elastic marks and the waist marks together. Zigzag the elastic on to the cloth, stretching it to fit as you go along. You will have to stretch the elastic between your hands as you sew with one hand behind and one hand in front of the machine foot. If the elastic is wide, you will need a double row of stitching to stop the elastic rolling. This is a tricky technique to master but once learnt it has countless uses. You can use it on cuffs and necklines as well as waists. It is particularly good on lightweight fabric. If you sew the elastic $1\frac{1}{2}$in (4cm) away from the edge you will get a frill.

3. Edge the waist with wide bias binding and thread elastic or drawstring through it. This gives a soft waistband and is good for underskirts and petticoats, as it does not add as much bulk to the waist as a band.

4. Turn over the top $\frac{1}{2}$in (1cm) of the waist to the inside and press firmly. Cut petersham to the waist measurement and stitch it all the way round, close to the top edge on the inside of the garment. Petersham is a sturdy, non-stretch ribbon that can be

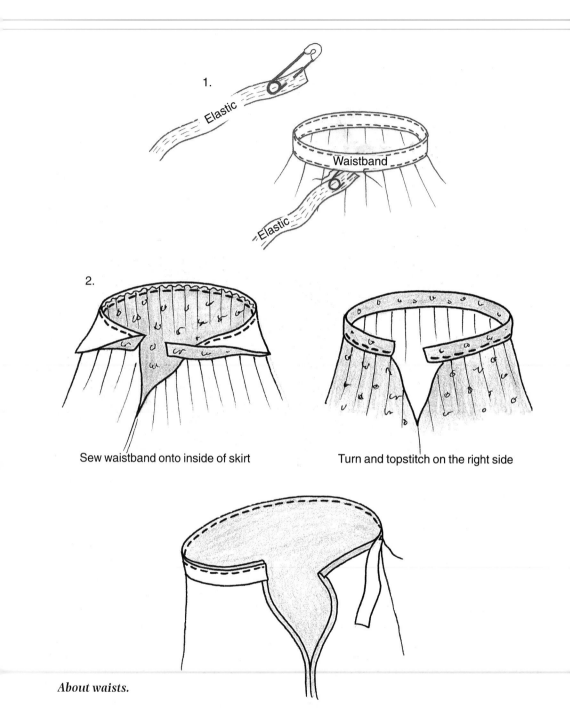

1.

Elastic

Waistband

Elastic

2.

Sew waistband onto inside of skirt

Turn and topstitch on the right side

About waists.

bought straight or curved to lie smoothly on the waist. It gives a firm waistband when the fullness of the garment has been taken in with darts or tucks, but is too stiff to work well with gathers or elastic.

Exercise 6: Finishing slit plackets

If a skirt or pair of trousers is not wide enough to slide over the hips, you will have to cut a slit, or elongate an existing slit, until it will go on without a struggle. This is called a placket. There are various ways to stop this fraying and give it extra strength. Here are the easiest to use on a costume.

1. Zigzag the edge. Strengthen the bottom of the slit with several lines of horizontal stitching or sew a small piece of tape across the end or overlap it with a little pleat, which you press and stitch in place.
2. Zigzag the edge, turn and press the smallest hem you can manage. Stitch this hem with a straight stitch.
3. Bind each side of the slit separately with a narrow strip of material cut from the same cloth as the garment. This will need to be at least $1\frac{1}{2}$in (4cm) wide but can be much wider if you need it for decorative effect. When you have done this, lay it on the ironing board as if the garment were fastened. Overlap the bottom of the slit to make it look as neat as possible. Press it, pin it if you need to, and strengthen with horizontal stitching.

Exercise 7: Gathers and pleats

Gathers and pleats behave differently on different types of fabrics, and the ways they are used vary depending on the garment. It may be more practical to try these exercises when you need to apply them to a particular costume, rather than working straight through them.

1. Sew a line of stitching about $\frac{1}{4}$in (0.5cm) from the edge of the cloth using the longest machine stitch. Do not finish off or trim the ends of the thread. Sew a parallel line $\frac{1}{4}$in (0.5cm) below it. Pull the two lower threads (the ones that came from the bobbin of the machine) gently, easing the resulting gathers along the line. When it has reached the required length, stitch in place on to its host between the two lines.
2. The same as 1 (above) but with just one row of stitching. This sounds quicker and easier but often takes longer in practice – if a thread breaks you cannot bodge it together so easily and have to start again. If you use this method, attach the gathers to the garment by sewing on top of the gathering line to hide it.
3. Some fabric is too heavy to gather by machine. If this is the case, hand sew a running stitch using button or some other strong thread. Fasten it securely at the beginning so that the thread does not pull through when you draw it tight.
4. Experiment to see how much material the pleats take up when you overlap or leave a gap between them. Look at the cloth you are working on. Sometimes stripes or checks can be used as a guide for the positioning of pleats. Otherwise, notch at regular intervals to mark the folds. Imagine a pattern of red and blue stripes. You might want to pleat it so that all the red is hidden and only the blue shows. When you have marked the position of the pleats, start machining them into place about $\frac{1}{2}$in (1cm) from the edge. Tuck the fabric of each pleat under the foot as you machine, matching notches as you go. Be sure to keep the pleats positioned at right angles to the edge of the cloth and the weight of the garment well supported, or all will go askew (you may need to pin the pleats in until you get the knack of this shortcut). When you reach the end, press firmly and run a second row of stitching

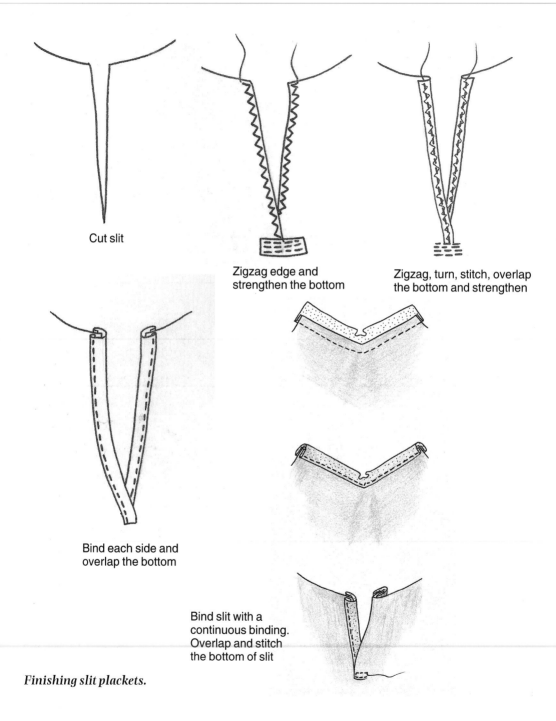

Cut slit

Zigzag edge and
strengthen the bottom

Zigzag, turn, stitch, overlap
the bottom and strengthen

Bind each side and
overlap the bottom

Bind slit with a
continuous binding.
Overlap and stitch
the bottom of slit

Finishing slit plackets.

parallel to the first and $\frac{1}{4}$in (0.5cm) below it to hold the pleats straight.

5. In a situation where a very heavy cloth has to be tightly pleated, or the pleats have to stick out from the securing band, the machine may rebel and you may have to resort to hand stitching. The edge to be pleated should be finished with facing, the position of each pleat measured and marked and each pleat sewn separately at regular intervals in position on the garment. This might happen on a heavy full skirt or a ruff. Use strong thread and firm stitches.

6. Some machines have a special foot for gathering and ruffling. If you do not have one, and you should see a fiendishly complicated looking machine foot with little levers, flanges and numbers in a jumble or car-boot sale, it is probably a ruffler discarded by its confused owner. If you can find one, buy it and experiment. If you can't work it out, take it to a sewing machine shop or a curtain maker and beg them to show you. It will save you hours or even days if you are ruffling about in the eighteenth century.

7. Gathering with elastic. This is very quick and very useful. However, it needs practice and confidence to make it work. Try it out like this:
a) Cut a piece of lightweight cotton 20in (50cm) long and 4in (10cm) wide.
b) Pencil a line along its length in the middle.
c) Cut a piece of very narrow flat elastic or round hat elastic 12in (30cm) long.
d) Use a medium stitch length and the widest zigzag setting. Attach the elastic to the cloth by stretching it along the line and zig-zagging over it. Be careful not to let the needle pierce the elastic – you are making a channel of thread to cover it and keep it in place. Use it with a circle of elastic on

Gathering with elastic.

puff sleeves, knicker legs, neckline frills and the like.

FASTENINGS

Fastenings have to be extra strong for use onstage as they are subjected to repeated vigorous movement and strain. An accidentally undone button or unfastened zip will rivet the attention of an audience and distract the attention of the actor.

Here is a list of some fastening methods with their uses and drawbacks:

- **Zips:** quick and easy to put in but impossible to mend in a hurry if they get jammed or break. Never use them when they are likely to be subjected to strain or quick changes.

Gathering.

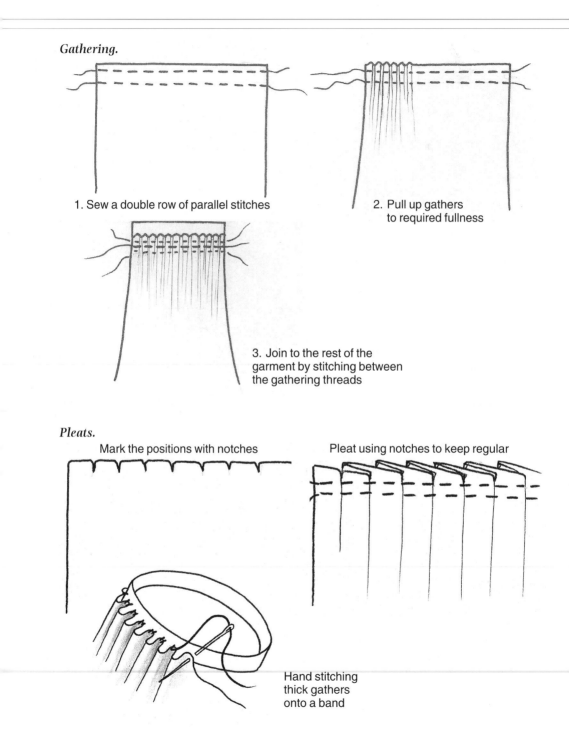

1. Sew a double row of parallel stitches

2. Pull up gathers
 to required fullness

3. Join to the rest of the
garment by stitching between
the gathering threads

Pleats.

Mark the positions with notches

Pleat using notches to keep regular

Hand stitching
thick gathers
onto a band

- **Hooks and eyes or hooks and bars:** reliable under strain and available in many sizes. They can also be bought already sewn on to tape, which can be machined on to the garment.
- **Press-studs (poppers):** good to hold cloth together neatly if the strain is not too great. Speedy and silent to undo for quick changes.
- **Velcro:** bulky, clumsy and difficult to do up neatly, but very easy to apply. Speedy to undo for quick changes but accompanied by an instantly recognizable loud ripping noise.
- **Buttons:** good for most occasions if you can manage the buttonholes.
- **Eyelets and lacing:** most good haberdashers sell tools for putting in eyelets. They work best on tight-woven cloth that does not fray easily. You can strengthen the cloth before you start with iron-on woven interfacing or special glue that prevents edges fraying. Always experiment on spare cloth before you start, as mistakes are hard to rectify.
- **Tapes:** old fashioned but easy to apply, alter and adjust, particularly for period costume where the bows will not look out of place. Tapes have so many uses that they deserve a section of their own.

Tapes and their uses

Tapes can fasten and adjust the fit of trousers, breeches, waistcoats, cuffs, collars, ruffs, skirts, bodices, jackets – anything where the ties would not look out of place. As a general rule, keep it simple so that the bow does not draw the audience's eye. Tapes are particularly useful if you are making a costume that is likely to be used in many different productions, as they are so easily adjusted by an inexperienced hand. Use plain, strong, narrow tape unless you want a particular effect such as bonnet ribbons for Pretty Polly or bootlace-

Fastenings

Somehow, an undone button looks less awful onstage than an undone press-stud or zip. Badly fastened velcro looks dreadful. It is relatively easy for an actor in a period play to do up a button onstage without looking too crass. The same cannot be said of other fastenings.

tied kneebands for Oliver Cromwell. Always turn the end of tapes in neatly and securely to avoid fraying.

Here is a list of some of the uses for tapes:

- As an adjustable back fastening. Use a safety pin to thread the tape through the entire channel. Pull through enough tape to tie one side of a bow. Fasten the tape securely within the channel at a point 6in (15cm) from this end with secure vertical stitching. Adjust the waistband so the tape is not gathered, and secure 6in (15cm) from the other end. This will enable you to adjust the back of the garment whilst leaving the front flat. It is particularly useful for bustles and other costumes where you need extra fullness at the back.
- At the back of trousers, breeches, jackets, waistcoats or bodices. Sew pairs of tapes 3in (8cm) either side of the centre back seam and tie to fit. Sew the tapes very securely at a point 3in (8cm) from the join of the garment. Sewing them 1–2in (2.5–5cm) in from the join will enable you to overlap the edges for a smaller actor or to leave a gap when you tie them on a bigger body.
- As the drawstring for a waist. Use a safety pin as a threader and a piece of tape long

enough to go round the waist and tie in a bow. Thread the tape right round the waist channel and stitch the centre point of the tape securely through the centre point of the channel so that it cannot be pulled out by mistake.

- Collars. Sew separate tapes to both sides. Sew one side at the very end of the collar and the other side 1in (2.5cm) in from the end. This will enable the collar to overlap when the bow is tied. Do not sew the tapes on the very end if you want the collar to meet edge-to-edge because the knot will force a gap to appear. Sew them $\frac{1}{2}$in (1cm) in from the edge.
- Side tapes. Cut four tapes 12in (30cm) long. Sew a pair on the waistband at each hip with a 6in (15cm) gap between them. This will enable you to adjust the waistband with a bow on each hip. Sometimes the fabric insists on slipping down out of these ties. If so, you can make it behave by attaching a separate little tape loop between each pair of tapes to thread through.
- Pulling in a continuous band such as breeches or kneebands. Find the outside edge of the band or the place where you want the bow to be. Sew the middle 3in (8cm) of the tape flat on to the band and tie to fit. You can use this method anywhere, even on the back of a pair of jeans, to adjust fullness. This method is good for taking in borrowed clothes as it can be unpicked fairly easily afterwards.

STIFFENING AND BONING

It is often necessary to stiffen fabric to make it heavier or stronger and the lining is a good way of adding weight and strength. There are many interlinings sold for this purpose. Be wary of the ones that bond to the fabric when ironed. You can end up with a bubbly effect after a few washes that will show clearly in the stage light. Always try these interlinings out on an offcut of the costume's cloth first and check that the bond is smooth and reliable. It is safer to bond these linings to facing or lining rather than the top cloth of the costume. You can use a firm-woven cloth as lining or interlining but make sure you wash it first in a hot wash to pre-shrink it, and that it will put up with the same regular washing or cleaning as its host.

Theatre costumes need to be strong to withstand energetic and sweaty wear. Fastenings should be sewn on to cloth that will withstand the countless buttonings and unbuttonings in the dressing room – if you suspect the fabric's strength, reinforce it before you attach the fastenings.

There are times when you will have to make a costume appear much heavier than it is. Thin foam rubber, wadding, flannelette and fleece can all be used. Fabric backed with a very thin layer of foam is wonderfully useful when you can find it, as are many less obvious materials. You can use bubble wrap, cardboard, hessian, paper cloth (like kitchen cloths), rubber, an old blanket, soft curtain interlinings – all sorts of odds and ends, provided they will not disintegrate during the run of the show. It can be a useful trick to interline the hems or edges of a garment with a narrow line of foam or soft cord to give an apparent weight and bulk to a costume.

Items such as bodices, sashes, belts and hats sometimes need to be boned to keep them rigid when they want to flop. Boning can be bought by the yard for you to cut to length yourself, or in separate corset bones of various lengths. The bones can be slid into channels of tape sewn on to the costume, or encased in tape and attached separately to the lining or seam. Make sure any stitching which shows on the right side

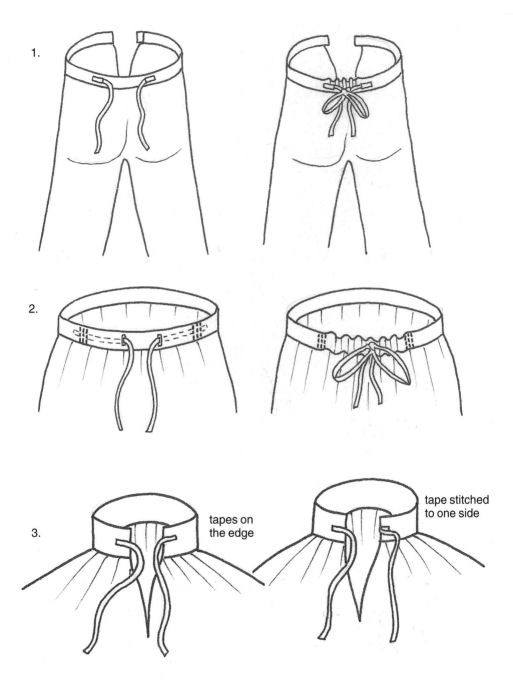

1.

2.

3. tapes on
the edge

tape stitched
to one side

About tapes and their uses.

of the costume is in an appropriate colour and carefully placed so that it will not show unless you want it to. Take care that ends of cut boning are well covered with tape and that the bones do not dig into the actress's armpits or waist.

All the techniques described in this chapter are simple once you know how. The first few times you try a new technique it takes ages, and the result may be clumsy. But it only takes a short time to teach your hands to make the effect you see and imagine, and you will immediately begin to reinvent the methods to suit your particular temperament. If you can find someone who will give you a demonstration of anything that bewilders you, it will help enormously.

5 PATTERNS

By the end of this chapter, you should be able to adapt a commercial pattern for costume use, match a design and cut your own simple patterns. You might not believe it until you try. Use period pattern-cutting reference books to see how the shapes of the pattern pieces vary to create silhouettes and how to create particular details. They may baffle you now, but have another look when you have worked to the end of the chapter.

It is a good idea to try these experiments in simple pattern cutting. A little practical experience will open a wardrobe full of possibilities. Use any old cloth so that you need not worry about working neatly to master the techniques described. Fold the material in half lengthways, iron smooth and cut through both thicknesses of cloth so that you end up with a right side and a left side of each pattern piece.

You will need the following equipment:

- Dressmaking scissors
- Paper-cutting scissors
- Tape measure
- 3ft (1m) rule
- Tailor's chalk
- Pencil
- Pins
- Weights: these are not essential but using them to weigh down the fabric can save a lot of pinning and can often act as an extra

Cutting the Cloth

Remember to cut the right- and left-hand sides of a garment as mirror images or you may end up with two right sides and no left. Lay the cloth right sides together, and cut both pieces at once. It is easier to be accurate if you cut notches and mark points of reference such as darts or pocket positions while the material and pattern are flat on the table.

hand. Paperweights, clean heavy pebbles or baked bean tins will do. Bulldog clips, clothes pegs (and teeth!) are all useful to clamp fabrics together.

MARKING THE FABRIC WHEN CUTTING

There are many shortcuts you can use on theatre costumes that might be too clumsy for dressmakers. The audience can only see the outside of a costume. Whilst the inside must be durable and comfortable, it will of course not be visible to the onlooker. Time spent making it look good may give you satisfaction, and sometimes pleases the actor wearing it, but it will not affect the audience. In fact, a strong, well-made costume tends to look good inside as well as out.

When you are cutting a costume there are innumerable points that need to be remembered until it is fitted, stitched and finished. It is easier to mark these on the cloth at the cutting stage when all the pieces are flat on the table and the design is clear in your mind. You can use traditional dressmaker's markings such as tailor's tacks and lines of loose tacking stitches, but here are some shortcuts to accurate marking.

Pin-Poking

Pin-poking is used to mark features on the costume that have to be symmetrical, such as front pockets or braiding. Place the two matching sections of the garment exactly together. Draw the shape and position of the pocket or braiding on one side and poke pins through the drawn lines to the other side. Make sure you put a pin at the very end of each line and anywhere where the line changes direction. Turn both pieces of cloth over together and put a little dot in the place where each pin emerges. Remove the pins and join the dots. Only draw on the right side of the cloth if you are certain the marks will be covered. If you are not sure, draw on the wrong sides and transfer the marking to the front at a later date using the same pin-poking method.

Pressing through

This works when you have applied a feature with a certain amount of bulk on one side of a garment and want to match it on the other side. Imagine you have stitched a patch pocket on one side of a coat. Place it pocket side down on the ironing board. Line up the other side of the coat on top of it, matching all seams and markings exactly. Press firmly under a damp cloth. You will usually see a slight outline of the pocket when you remove the cloth that you can use as a guide. This unorthodox method does not always work, but is well worth trying because it is so quick and accurate.

Darts

Mark the seam allowance edge of the dart with notches and the point with dot and pin-poking.

Dots, crosses and lines

The point of a dart or the turning point of a line of stitching, usually marked with a tailor tack in dressmaking, can be marked with a pencil dot or a chalk cross. Guidelines for tucks, braid and so on, may be drawn directly on the cloth as long as they are not likely to show or run in the wash.

Notches

This section may seem a long haul but on no account be tempted to skip it. Twenty minutes spent understanding the uses of notches will save you hours of pinning, tacking, unpicking and other dull, fruitless labour.

A notch is a little slit in the edge of a pattern piece. It is usually about $\frac{1}{4}$in (0.5cm) long but may be longer on fur and shorter on lightweight silk. It aligns with a similar notch cut in an adjoining piece. On dressmaking patterns, these are marked with little black triangles at the edge. They may be in groups of two or three to further clarify the information they give, and are numbered to make them

easy to match up. When you are cutting the garment, it is quicker to make a tiny slit in the cloth instead of a triangle, but you must be careful not to hide this from yourself if you are neatening the raw edges with a zigzag stitch. You can mark notches with chalk or pencil instead of cutting them. You rarely need to number notches when you cut your own patterns. They will automatically remind you of the things you thought of when you were deciding on the shape.

Notches are a most useful aid to making things succeed the first time and will forewarn you of a mistake. If your notches do not coincide when you are stitching a seam, something is probably amiss and you should stop sewing and check that everything is in the right place. Get these little notches so ingrained into your cutting and sewing habits that it becomes impossible to forget them.

Notches can be used to mark:

- How to match seams correctly and accurately.
- The place where a seam has to join another pattern piece at a particular point, such as a shoulder seam meeting the top of a sleeve.
- The central point of a pattern piece.
- The amount of seam allowance.
- The width and position of darts, pleats and tucks.
- The fullness and position of gathers.
- Sizes, if you are using the same pattern for a number of different bodies in a chorus.
- The position of braid and decoration.
- The front and back of a pattern piece. The front is usually marked with a single notch and the back with a double. Be particularly careful to do this on armholes and sleeves. This will stop you making mistakes such as putting a sleeve in the wrong armhole.
- Discrepancies in stretch. There are times when the top and bottom cloth stretch at different rates when being machined. It can

be a long, boring job to unpick the seam when you find at the end that you have a foot of stretched cloth and nothing left to sew it to. Regular notches will allow you to notice and rectify any irregularity as you stitch along the seam.

Cutting the Cloth (2)

Notches will not tell you whether you are looking at the right side or the wrong side of the cloth. If there could be any doubt about this, mark the wrong side of the cloth with a chalk cross on each pattern piece you cut. Use a chalk arrow if you need to remind yourself of the downward direction of the cloth.

Exercise 8: Understanding the use of notches.

Copy the notching diagram on page 67. Cut out the paper shapes accurately. Make sure you can see all the markings clearly.

1. Position the shoulder seams on top of each other as if you were going to stitch them together. Notice that if you had confused the neck edge with the armhole edge and reversed one piece, the notches would not have matched, which would have given you advance warning of a mistake that is easy to make on some low-necked costumes, as the armhole and neck hole look quite similar.
2. Notice how the centre front is notched at the neck and hem so that whatever the overlap at the front you will be able to find the centre point. It is often useful to rule a chalk line between these two notches so that you can pin at a precise central line at fittings.

3. The notches at the end of each seam mark how far in from the edge you must sew. This is called the seam allowance.

4. Look at the neck and armholes. The front is marked with a single notch and the back with a double.

5. Position the front and back side seams as if you were going to sew them together. Notice that if you tried to position one upside-down, the notches would not match.

6. Look at the braid line at the bottom of the sleeve. The notches at each end of it will tell you how far from the edge you must stitch the braid to make sure the decoration ends up as a continuous line when the sleeve is stitched together.

7. Fold the sleeve in half as if you were going to join the underarm seam. Notice the central notch at the top where it will join the body of the shirt at the shoulder. This is a particularly useful mark if you have a lot of gathers at the top of the sleeves – it will help you space them evenly and set the sleeve in straight. Notice the central notch at the bottom of the sleeve, which you might find useful if you need to narrow it, apply decoration or add a cuff. It is often useful to have central points marked, even if you do not anticipate using them.

8. Notice that the sleeve is too big for the armhole and will need to be gathered or pleated between the notches to make a puffy top to the sleeve.

9. The front of the armhole seam is marked with a single and the back with a double notch. Experiment to prove to yourself that as long as the notches match you cannot put a sleeve in the wrong armhole (unless, of course, you put it in upside-down or inside-out, in which case the best thing to do is to have a bar of chocolate, go for a little walk and start again).

When you have completed this exercise, read though the whole notching section again and make sure you understand it. After you have used notches regularly, you will develop them into a shorthand language of your own, which will be an enormous help and enable you to make costumes more quickly.

UNDERSTANDING THE SHAPE OF CLOTHES

You will find the following exercises useful if you have never made clothes before, as they will demonstrate to you the structure of the garments. Work through all these exercises in order. Much of the information relating to one garment will be relevant to others.

Exercise 9: Understanding how trousers are cut

Find an old pair of trousers or shorts and take them apart to see how they work.

1. Lay them flat on the table with the centre back and centre front seams on top of each other. Notch the waistband and the hem at the side and rule a chalk line between the notches. Do not cut this yet.

2. Cut through the centre back seam and the centre front seam.

3. Cut through the inside leg seams. You now have two separate pieces.

4. From now on you will work with one piece, so spread the one with the chalk line out on the table and chuck the other away. The shape of the pattern and how it is put together becomes clear. The centre back seam has a deeper curve than the centre front to allow enough cloth to cover the bottom. Even a small bottom sticks out a bit.

5. Cut a single notch in the curved centre front seam (the seam where the buttons would be on a pair of jeans).

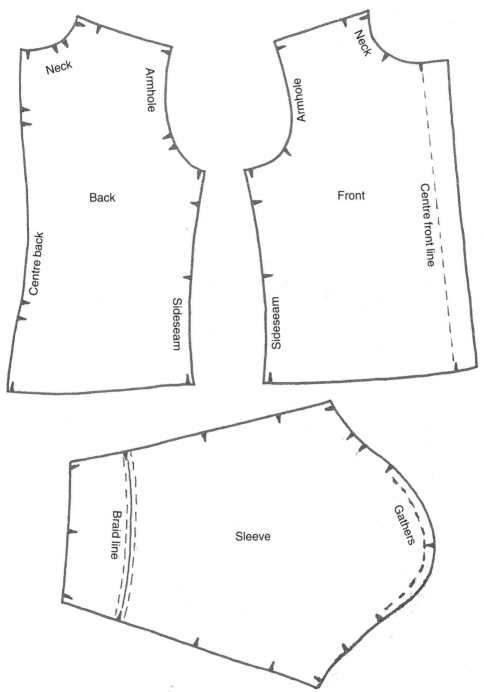

Neck

Armhole

Back

Centre back

Sideseam

Neck

Armhole

Front

Centre front line

Sideseam

Braid line

Sleeve

Gathers

Understanding how patterns work.

6. Cut a double notch in the curved centre back seam. If you think you might get muddled later, mark the pieces F (front) and B (back), though the notches should remind you (double for back, single for front).

7. Cut down the side chalk line. This may be on an existing side seam or not – it depends on the cut of the trousers. If, like jeans, they have a strong overlapping seam, trim the thick bit off as it will get in your way later.

8. Lay the two resulting pieces on top of each other, matching the side seams, and mark this edge by cutting three separate notches at irregular intervals through both thicknesses. Do not expect the pieces to match in other places – one is the back and one the front.

9. Match the inside leg seams and mark by cutting two separate notches at irregular intervals down their length. The irregularity of the position of the notches means you cannot put the trousers together upside-down, which can be quite an easy mistake to make with breeches or shorts.

These two pieces have now become a pattern. Keep them to use later.

Exercise 10: To make a pair of simple trousers

This exercise will help if you are frightened of using commercial dressmaking patterns. Pyjama or sportswear patterns are usually the simplest to adapt for garments such as trousers, breeches, bloomers and pantaloons. A very simple pyjama pattern may only have one pattern piece as the front and back with no side seam.

1. Buy or borrow a dressmaking pattern for a pair of pyjamas or simple trousers.

2. Do not be alarmed by the mass of information contained in the instruction sheets. You will not use all of it, and after some practice, you will only refer to the instruction sheets on a very complicated pattern or when you are learning a new technique. You will need to know the seam allowance, which is usually $\frac{5}{8}$in (1.5cm). The instruction sheet will tell you the amount allowed if it is not marked on the pattern. It will also tell you the body measurements for which the pattern is cut.

3. The instructions will tell you near the beginning which pattern pieces you need for the particular garment you are making. Imagine you are going to make the trousers.

Taking old clothes apart to understand how patterns work.

The pieces will have a number or letter that will correspond with a number or letter on the pattern piece.

4. The pieces will be named as well as numbered. There may be pockets or frills that you do not need to use, so put them all aside and keep out only the bits you want.
5. There will be instructions for laying out the pattern pieces on the cloth. Use them if you feel you need to, or sort it out for yourself, making sure you pay attention to the grainlines on the pattern.
6. Find the sewing instructions relating to the trousers. They will instruct you how to make the trousers as if they were going to be worn in real life without using all the shortcuts that can be used on costumes.
7. If you feel it would help your confidence to follow these instructions exactly and make a real pair of trousers, do so. You will find it much easier than it appears. Otherwise, proceed to Exercise 11, which is more informal.

MAKING MINIATURE CLOTHES

Making clothes in miniature is not only an easy and cheap way of learning, but also excellent practice. Indeed, it is often the best way to work out and demonstrate a transformation or tricky bit of cutting.

The diagram for Exercises 11, 12 and 13 shows a copy of a typical pyjama trouser pattern in miniature. Although it is tiny and not printed with lots of other pattern pieces on huge and muddling sheets of tissue paper, it is basically the same as the piece or pieces you used in Exercise 10. You will recognize the two most important lines, which are the curved centre back and centre front seams. These are the most difficult shapes in a pair of trousers for the inexperienced pattern cutter to invent. You can borrow them from any trouser pattern and make up the rest – or at least you will be able to after these exercises. Copy the diagram three times for use in the exercises.

Exercise 11: To make a miniature pair of trousers

Identify the following points on the pattern before you start:

- The information written on the pattern piece.
- The grainline. This tells you how to lay the pattern on the cloth. It should be parallel to the selvedge on the downward grain of the cloth. On a collar pattern, the grainline may slant to show you that you must cut on the bias.
- The front and back are cut in one piece without a side seam so you are looking at one front and one back of the garment. You will have to cut the mirror image of this piece in the cloth to get the other front and back. It is easiest to fold the cloth right sides together and cut both pieces and all notches at the same time.
- The fold line at the waist and hem, which shows the hem allowance.
- The dotted lines on the seams, which show the seam allowance.
- The extension flap on the centre front. This is to make a fly front.
- The dot on the centre front line. This marks the lowest point of the fly opening.
- The double lines to lengthen or shorten the pattern. Cut the pattern and spread it apart at those points if you want to lengthen the trousers, or overlap it if you want to shorten them. The lower lines alter the leg length, the upper ones alter the crutch to waist length.

Use one of the three copied diagrams to make the little trousers in lightweight cotton. You will need a piece 10in (25cm) long and 15in (38cm) wide.

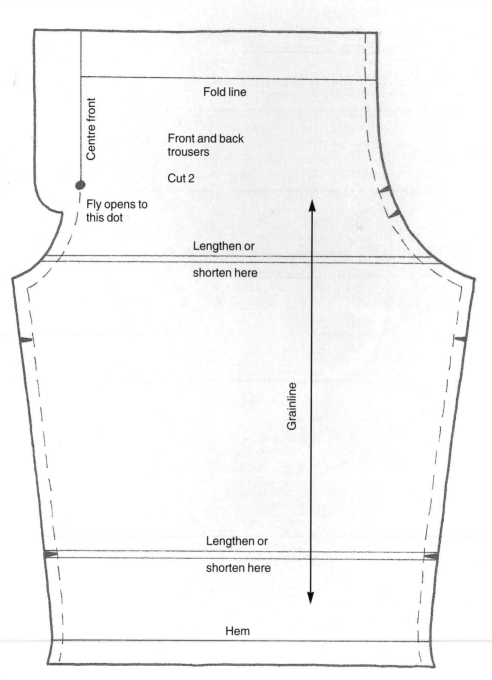

Making miniature trousers.

1. Fold the cloth in half lengthways – right sides together and iron it flat.
2. Lay the pattern piece on the cloth, keep it still with a couple of pins or a weight, and cut it out.
3. Mark the information on it with notches (*see* Exercise 8). Use the pin-poking method to mark the dot (*see* page 64).
4. Take the paper off the cloth.
5. Sew the curved centre back seam right sides together, matching the notches.
6. Sew the short front seam together from the dot to the crutch leaving the fly front open.
7. Lay the work on the table with the centre front over the centre back so that you can see which inside leg seams to sew together.
8. Sew the inside leg seam right sides together from the bottom of one leg, up and across the crutch and down the other leg, matching the notches.
9. Turn the work right side out and press, folding the fly flap to the inside on the centre front fold line on one side only so that it can overlap the other side on the centreline. Make sure the centre front

notches, one folded and one flat, lie on top of each other.

Exercise 12: Altering the length of a pattern

Use the second copy of the diagram to learn how to alter the length of a pattern to suit the measurements of the actor.

To alter the leg length

1. Cut the pattern between the double lines along the 'lengthen or shorten here' line on the leg of the trousers.
2. Lay the pieces on the table as if they had not been cut.
3. Part the split or overlap it until the inside leg seam matches that of the actor. Do not move it sideways. You may need to pin the pattern pieces on the cloth when you are cutting to make sure the lines stay parallel. If they are not parallel the seams will not match when you make-up the trousers.
4. When you do this, you will often notice a discrepancy where the side seams meet. Just

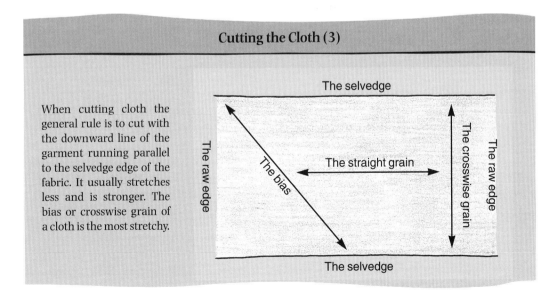

Cutting the Cloth (3)

When cutting cloth the general rule is to cut with the downward line of the garment running parallel to the selvedge edge of the fabric. It usually stretches less and is stronger. The bias or crosswise grain of a cloth is the most stretchy.

The selvedge

The raw edge

The bias

The straight grain

The crosswise grain

The raw edge

The selvedge

smooth it out with a chalk line or scissors when you cut.

To alter the length from crutch to waist
Costume trousers are often cut to sit high on the waist and worn with braces so that no gaps appear during vigorous movement. The easiest way is to extend or shorten the top of the trousers the required amount.

Otherwise:

1. Cut the pattern between the double lines along the 'lengthen or shorten here' line above the crutch of the trousers.
2. Lay the pieces on the table as if they had not been cut.
3. Part the split, or overlap it until the crutch to waist measurement matches that of the actor. Do not let it move sideways. You may need to pin the pattern pieces on the cloth when you are cutting to make sure the lines stay parallel.
4. Re-draw the curves if necessary. When you do this, you will often notice a discrepancy where the side seams meet. Just smooth it out with a chalk line or scissors when you cut.

This method may also be used to alter patterns for shirts, dresses, sleeves and so on.

Exercise 13: Altering commercial patterns for costumes

Use the third copy to adapt the trouser pattern to make a pair of baggy breeches with very wide legs. In the following exercise, imagine you are laying out the pieces on doubled cloth to use as a pattern for a costume. This business of imagining is not only an easy and cheap way of learning, but also excellent practice.

1. Draw a horizontal dotted line parallel to the upper 'lengthen and shorten here' line and about half way between crutch and waist. This is the hipline, and must be wide enough for the actor's bottom however else you alter the trousers.
2. Fold the pattern in half lengthways, matching the crutch points. The fold would run down the side of the trousers if they were made up. Rule a line down this fold. Mark AA each side of the top of the line and BB each side at the bottom. Cut along the line. You now have a trouser pattern in two pieces with side seams.
3. Write 'front' on the piece with the fly and 'back' on the other bit. Write CUT 2 on each piece.
4. Place the two pattern pieces on a sheet of A3 paper with the side seams butting each other at AA and BB.
5. Keep AA and BB level and part the two pieces keeping them parallel until you could put your fingertip between them. This is an easy way to make them fit a larger size or to make them baggy all over and gathered at waist and knees. Overlap this seam to make a smaller size. Keep lines level and parallel.
6. Replace the pieces side by side and overlap BB. This will narrow the legs but not the waist. When you do this for real, you have to take care that the hip measurement does not become too small. If this happens you will have to narrow the legs below the hipline. You can do this by re-cutting the shape of the inside and/or outside leg seams, or you can cut a vertical split in the middle of the front and back pattern pieces from trouser hem to hipline and overlap the pattern to the required size. It's like making a giant dart in the pattern to alter its shape.
7. Replace the pieces side by side and spread them at the bottom in an upside-down 'V' shape until you could put the tip of your finger between them. Keep AA together.

72

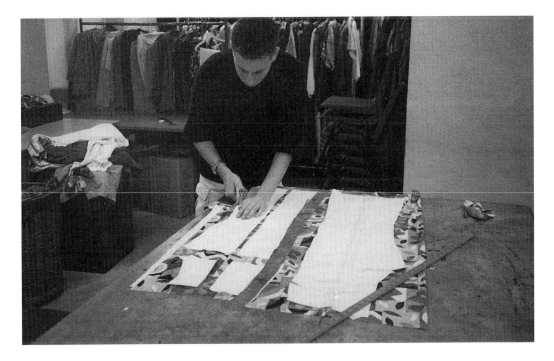

Enlarging a trouser pattern by spreading the pieces apart on the cloth.

Note how trousers cut like this would be wider at the bottom than at the top. When you made them they would be baggy legged and snug round the waist. If you overlap at AA you would make the waist smaller. The widened hem could be pleated into a band round the knee for breeches or stiffened to stand out like clown's trousers.

8. Replace the pieces side by side and open them at the top. Keep BB together. Cut like this they would be baggy bottomed and snug round the lower leg.

9. Keep AA together and swivel the pieces outwards from central vertical line drawn on the paper. Do it gradually, a fingertip width at a time, marking the position of BB with a dot at each move. Do not allow AA to overlap – the waist of the breeches would be too small if it did.

10. When you have moved it four or five times make sure AA is still in position and the two sides of the pattern are equidistant from the centre line at BB.

11. Draw round the outside edges of the pattern in their new position.

12. Look at the waist of the pattern – it has changed shape. Smooth out the sharp angle that has appeared with a curved line.

13. Draw in the bottom of the legs, joining the dots at the hem with a smooth line. Note that it is no longer a straight line, it is a curve. In fact it is an arc of a circle. There is nothing to stop you extending this arc. The seam lines have not changed. The notches will still match with the other pattern pieces. But the finished garment will look completely different. You can use this

method of spreading on an arc for cutting coats, cloaks, skirts, sleeves, hats, trousers, bags, collars and dresses. You will usually find it is better to move both sides of a pattern out from a central line. (You could try this on the sleeve pattern from Exercise 8 to make a hugely gathered top to the sleeve. Start with cutting a vertical line from shoulder to elbow. Make sure the underarm seams and notches continue to match.)

14. Take the pattern pieces off and look at the drawing. This is your basic pattern for the breeches. Try making them in lightweight cotton. Work out how much cloth you will need by measuring the widest point and doubling it for the width measurement. Add a little to the waist to hem measurement for the length. Remember you will cut the length on the lengthwise grain of the cloth.

15. Cut out and make the breeches. It will help to consolidate the information from previous exercises in your mind. Think about how you would finish the waist and hem.

Reinforcing trousers

Look at the crutch on a pair of trousers. Where the inside leg seams meet the front and back seams they form a cross. Always reinforce the cross of seams at the crutch on costumes. If they split, that is where the problem will start. Few things upset a performance more than split trousers.

Exercise 14: Taking measurements

How to measure the figure

Here is a list of the sort of measurements you might need to cut costumes. Of course, you will not need them all every time, and you will sometimes need extra ones for particular costumes such as a pantomime horse or the Hunchback of Notre Dame.

- **Waist:** tie a length of string snugly round the waist to mark the place. It is the line where people bend when they touch their toes and not necessarily where they wear their trousers.
- **Bust/chest:** measure round the widest part under the arms making sure the tape does not slip down at the back.
- **Hips:** the widest part. This can sometimes be the stomach and not the bottom.
- **Nape to waist:** the nape is the small bone at the back of your neck that you can feel when you bend your head forward.
- **Waist to knee:** level with the crease at the back of a bent knee, or from the side front waist over a bent knee for breeches.
- **Waist to ground** (or skirt or trouser length).
- **Inside leg:** from crutch to ankle.
- **Outside leg:** from waist to ground.
- **Across back:** about 3–4in (8–10cm) down from the shoulder where the armhole seams would be if the person was wearing a tight-fitting leotard.
- **Arm bent:** shoulder to wrist round the outside of the elbow.
- **Rise or crutch to waist:** the length measured from chair seat to waist up the side seam when the actor is sitting on a firm chair.
- **Circumference of head, neck, wrist, knee, ankle** and so on: when appropriate.

Shoe size

Ask if the actor has difficulty buying comfortable shoes. If he does, try very hard to

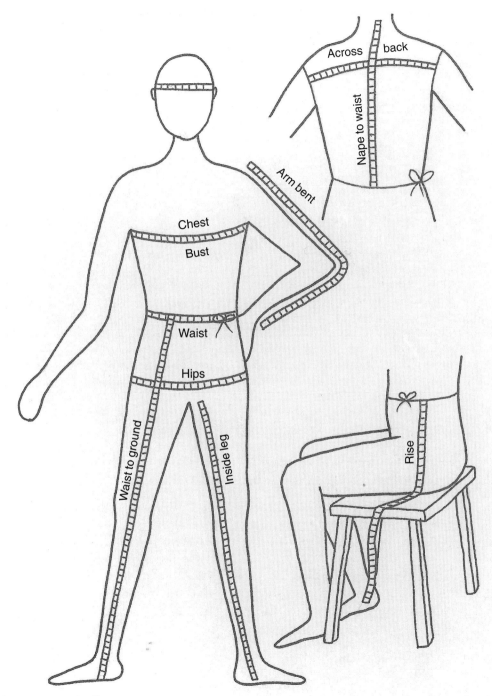

Across back

Nape to waist

Arm bent

Chest

Bust

Waist

Hips

Waist to ground

Inside leg

Rise

How to measure a figure.

have the costume shoes available at an early stage of rehearsal to avoid last-minute problems.

Height and build
Details of height and build (and age if it is a child) are useful if you cannot see the actor before you cut the costume. This information will help to provide you with a rough picture of the body you are cutting for.

Most of the pattern cutting in this book is for costumes that do not require very precise fitting and will adjust easily to a variety of sizes. However, you will need more precise measurements when you feel confident, or have no choice about, making more complicated outfits

Exercise 15: Making a pair of trousers, shorts or breeches

To make a real pair of trousers, shorts or breeches, use the old pair you cut up in Exercise 9 as a pattern and the information you have gleaned from the preceding exercises. Draw a sketch of the trousers you want to make. As you are using the pair you cut up in Exercise 9, choose a slightly different shape to exercise your pattern altering skills. Try not to use pins unless you absolutely have to – use weights to weigh down the pattern on to the fabric and trust your notches to keep you accurate when sewing. Work quickly without worrying too much. You are trying to master a method, not to create the perfect garment and you are learning costume making, not dressmaking.

1. Fill in this chart:

 Waist
 Hips
 Rise
 Waist to hem

2. Work out the length of cloth you will need by adding 10in (25cm) to the waist to hem measurement. Your cloth may not be wide enough to cut all the pieces side by side and you may need double, treble or even quadruple the length if you are making really wide trousers.

3. Lay the cloth, doubled right sides together as always, on the cutting table.

4. Using the pattern from Exercise 9, draw out the trousers you want to make using all your newly acquired skills. Be sure to allow sufficient room to accommodate the hips, but do not worry about cutting the waist to fit exactly. Cut the rise with a 3in (8cm) extra allowance at the waist and allow 2in (5cm) at the hem, or more if you want turn-ups or a high waist.

5. Sew the trousers together but do not finish the waist and hem.

6. Put the trousers inside-out on the wearer and tie elastic round the waist over the trousers. Pull the spare cloth up through the elastic until the trousers sit at the right level at the crutch and hang nicely. Mark the position of the elastic on the cloth all the way round one side of the front and back with chalk or pencil. This will be the correct position for the finished waistline and will be copied to match on to the other side. (See page 98.)

7. Make the waist fit with elastic, pleats, tucks or darts. Again, mark the fitting position on one side of the front and back, and match the other to it.

8. Cut an opening or unpick the top of a seam if the fitted trousers will not come off over the hips.

9. Copy the markings so that both sides match.

10. Finish the waist, and opening if there is one, using any of the methods from Chapter 4.

11. Mark the position of the hem and stitch it.

If you make a mess of this the first time, try again. With experience, you will be able to whip up the simplest pair of trousers in half an hour but it may take you a day the first time. You can cut a new opening or open one of the seams to make a placket and use any appropriate method from Chapter 4 for the hems, plackets, waist or flies.

Now you understand how trousers are made, you will find it relatively easy to learn how to alter the size and shape using a standard dressmaking pattern or to cut your own pattern to match a sketch. Keep learning better, quicker and neater ways to do things as your experience grows.

Each time you make something, you will use new techniques and perfect old ones. You will find that you can borrow cutting lines for difficult shapes from all sorts of patterns using the principles learnt in these exercises. You can use the lapels from one pattern, the sleeves from another, the bust darts from a third, and manage to fit them all together. You will also understand the instructions and patterns in costume reference books which will show you how to place seams and cut the sort of shapes not used in clothes today.

Cutting to Size

The most common mistake when you start cutting clothes is making them too small. Alterations to make things smaller are generally easier than those to make things bigger. Check with a tape measure or ruler before you cut and get used to imagining how much length is used up by a curve. Allow 3in (8cm) extra on measurements when you cut, not forgetting to include the $\frac{1}{2}$in (1cm) or more seam allowance which will be used up in the turnings on each seam.

Exercise 16: Understanding shirts or blouses

The easiest way to understand how a shirt is constructed is to take an old one to pieces. Choose an ordinary, straightforward shirt or blouse with a collar and cuffs. Use a ruler to draw straight lines, and cut neatly and accurately.

1. Open the shirt front by undoing the buttons or cutting it down the middle.
2. Cut off the collar. Collars are sometimes made in two pieces. If this is so, cut off the whole collar.
3. Rule a line down the exact centre back of the shirt and cut down it. From now on you will only be working on half the shirt.
4. Cut off the cuff carefully and close to the stitching all round.
5. Cut the sleeve from the body of the shirt in the same way, keeping close to the stitching all the way round the armhole. Mark the central point at the shoulder with a notch, the back with a double notch, and the front with a single notch.
6. Mark the central point of the cuff end of the sleeve with a notch.
7. Cut the sleeve along the underarm seam and lay it out flat.
8. Look at the cuff end of the sleeve. It may have been cut with a slit to let the cuff unbutton on the outside edge of the wrist. If there is such a slit, pin it together and ignore it – it is much quicker and less complicated to incorporate the slit in the underarm seam and it will be hard to tell the difference onstage.
9. Lie the body of the shirt on the table, folded flat. Notice how the scoop at the front of the armhole (marked with a single notch) is deeper than the scoop at the back of the armhole (marked with a double notch) – this is to allow easy forward movement of the arm. Some shirts will not show this detail.

10. Notice how the neckline at the front is cut lower than the back so that the throat is not constricted.

11. Cut a notch at the sleeve and a notch at the collar edge of the shoulder fold. Rule a line between the notches and cut along it. This may or may not be a seam line – it depends on the cut of the shirt.

12. Cut down the side of the body of the shirt, separating the front from the back.

13. If the armhole is tight at the armpit, you could cut deeper at the side seam at the armpit to loosen it. Make sure the side seams at front and back stay matching.

14. If the armpit is tight at the front, you could scoop out a deeper curve to allow for a free forward movement of the arm.

15. Pin the shoulders together and you will be able to see how a shirt, blouse, jacket or waistcoat is put together. Notice how at this point you could spread it out and copy the half neck shape for a facing pattern.

16. Look at the collar. Fold it in half, notch at the centre back and then open it out. Notice how you could change the shape of the collar as long as the line where you cut it from the neck remained the same length. You could alter its shape by cutting and spreading, or overlapping in exactly the same way as you did in Exercise 13.

17. Drape the half garment on a woman or dressmaker's dummy. Put a dot on the point of the bust. Notice that you could make a bust dart from that point to the side seam, the waist, the shoulder or the centre seam to take in fullness.

18. Unpin the shoulder seam and fold the front in half lengthways. Notch top and bottom.

19. Rule a line between the notches and cut along it marking AA, BB, top and bottom. Leave it joined at the bust point by a thumb's width. You will see that you can alter and re-draw its shape just as you did the trousers.

20. Experiment by pinning these pieces on the dummy or a person in a tight leotard for whom the original shirt would have been too big. Try to fit the pieces around one side of the body like a second skin. Pin the centre front and centre back of the garment so that it stays aligned with the centre of the body. This is important as you are only working on half a garment and will cut the other half to match. Do not worry about variations you make in the size of seam allowance or darts. Just try and make sure the shoulder seam stays on the shoulder, even if you have to unpin it completely and create an entirely different seam line. You will find it easier the first time if the side seam stays at the side, but as you gain experience you will be able to shift seams to wherever you want. Make sure the centre front and back lines of the cloth stay aligned exactly to the centre of the body. Cut the cloth, reshape the arm and neckholes, overlap it, unpin and re-pin it. Be brave about altering the symmetry of shoulder and side seams – it is not important for the turnings to be even. Try and make it fit as closely as possible. Remember how you learnt to make darts from the bust point.

21. When you have made it fit as well as you can, take it off the dummy or model. It will look a terrible mess. Tidy it up by trimming the seam allowances and notching, and drawing in the new seam lines and hemlines. When tidied up it will be a pattern for a fitted bodice.

22. Now try making a fitted bodice or doublet from a commercial pattern that is close to the size and shape of a costume you have designed. Alter the pattern to suit your design and use the above method to make it fit exactly. Be brave about repositioning seams and darts. Use any old cloth so that you don't worry about mucking it up.

23. Experimenting with these examples will show you the way a pattern works. It may seem a waste of time and money to practise on real cloth, but it is the only way to learn quickly and will teach you how to achieve the shapes you need as nothing else can. The cloth can be old, cheap and ugly and you can chuck it away once you understand the ideas. You will find that you can now look at most patterns and understand them. The Bibliography lists some excellent publications covering more precise methods of learning to cut patterns if you find this trial-and-error one too daunting.

PATTERNS FOR BASIC COSTUME

Once you understand how these shapes work, you can make simple and adaptable costumes. You can cut patterns out of large sheets of paper or cloth, or simply reproduce them directly on to the fabric for the garment, drawing or writing on the wrong side with pencil or chalk. The notches are marked on the first pattern but not on subsequent ones. This is so that you begin to create and practise your own code of notches. The instructions for making become less precise as you work through the exercises and gain confidence in your own ability to sort patterns out for yourself. Discrepancies between inches and centimetres are because the patterns are very adjustable and it is easier to work with round numbers.

The measurements on the diagrams for trousers are for people measuring approximately:

Waist	32in (80cm)
Hips	40in (100cm)
Rise	13in (30cm)
Inside leg	32in (80cm)

The measurements on the diagrams for tops and tunics are for people measuring approximately:

Bust/chest	38in (95cm)
Nape to waist	16in (40cm)
Wrist to wrist	55in (140cm)

The clothes are very adaptable and, if made to these sizes, will fit people if they are a size or two larger or smaller than the measurements.

TROUSERS

Trousers 1
These trousers, breeches or pantaloons are useful to suggest some non-specific time in the past when a baggy trouser silhouette is

Trousers 1.

appropriate. They are fitted by ties at the waist and can have ties at the hem if necessary. The cloth required will be twice the length from waist to hem plus 8in (20cm)

1. Halve the hip measurement and add 6in (15cm) This is the hip width of the trouser pattern.
2. Add 4in (10cm) to the rise measurement. This is the length from crutch to waist of the pattern.
3. The inside leg should be an appropriate length for breeches or trousers plus hem allowance.

4. Lay the cloth out with right sides together.
5. Copy the diagram for 'Trousers 1' on to the cloth with chalk or pencil.
6. Cut it out, not forgetting to notch.
7. Sew the front and back seams from crutch to waist.
8. Sew the inside leg seams, reinforcing the crutch with a double row of stitching.
9. Hem the waist.
10. Hem the legs.
11. Stitch ties 3in (8cm) below the waist hem at each hip with a 6in (15cm) gap between them.
12. Stitch ties at each outside leg if required.

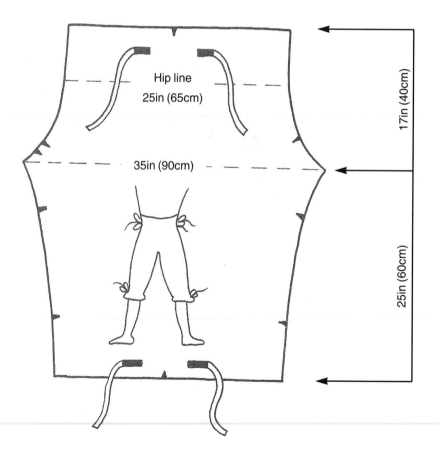

Hip line
25in (65cm)

35in (90cm)

17in (40cm)

25in (60cm)

Pattern for trousers 1.

80

13. If, on fitting, they are still too baggy at the waist, add an extra pair of ties at the centre back.

Trousers 2

Use firm, slightly stretchy material such as a thick cotton or mixed-fibre jersey. Even 5 per cent of lycra or elastic fibre in the cloth will make it hang better and be less likely to go baggy at the knees and bottom. The cloth required will be twice the length from waist to heel of the wearer plus 8in (20cm). If the cloth is very wide or stretchy and the wearer is slim, you may only need one length, folded in half lengthways. These trousers will fit fairly snugly. Adjust the pattern if you like, to make them fit as closely as tights or leggings, or to be loose and floppy like a tracksuit. These trousers do not have a side seam. If they are tight, they may benefit from a loop of elastic sewn to hook under the foot.

1. Measure the hips of the person who will wear them.

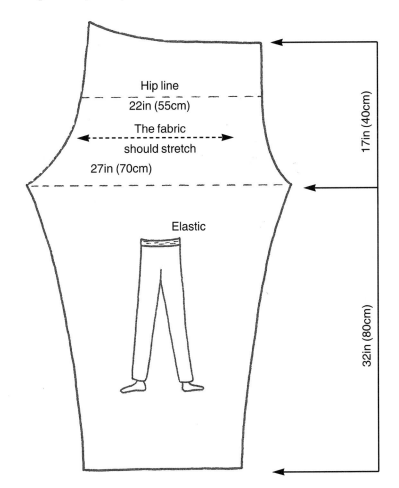

Pattern for trousers 2.

2. Halve this measurement and add 2in (5cm). This is the hip width of the trouser pattern.
3. Add 4in (10cm) to the rise measurement. This is the length from crutch to waist of the pattern.
4. Add 1in (2.5cm) to the inside leg length.
5. Fold the cloth right sides together. Make sure you cut so that the stretch of the cloth runs across the fabric, or the trousers will not stretch enough to pull on over the hips.
6. Copy the diagram for 'Trousers 2' on to the cloth.
7. Make the trousers using a stretchy seam stitch (*see* page 47) and reinforce the crutch with a double row of stitching.
8. Fit the trousers and mark the waist height (*see* page 98) and hem position.
9. Hem the waist and thread with elastic.
10. Hem the legs, sewing on elastic loops if you wish.

SHIRTS, TUNICS AND BLOUSES

Shirt 1

This is shaped like a long-sleeved T-shirt. It is cut to hang to below the hips like a short tunic, but could be full length or cut down the front like a coat. Draw the pattern on paper or directly on to the cloth.

1. Measure the length from the nape of the neck to finished length. This is the height of the stem of the 'T', which in this case is 30in (75cm). You will need twice this length plus 6in (15cm) of material for the shirt. Unfold it, iron it flat and fold it in half widthways.
2. Measure the wrist-to-wrist measurement plus 8in (20cm) along the fold and mark the central point with a C.
3. Draw a line parallel to the fold and 10in (25cm) below it. Mark the central point D. This makes the cross of the 'T'.

Shirt 1.

4. Draw a line from C through D to the bottom of the cloth. This will give you a centre front line. If you are making a jacket, you would cut the front open down this line.
5. The width of the stem of the 'T' is half the chest measurement plus 6in (15cm). In this case it is 25in (65cm). Draw the stem of the 'T' centrally below the line, like a rectangle.
6. Mark the two points X.
7. Measure 6in (15cm) towards the wrist and towards the waist from the point X. This is where the underarm curve starts and finishes.
8. Finish drawing the pattern as in the diagram.
9. Cut 3in (8cm) either side of C, along the fold.
10. Cut a 10in (25cm) slit down the front to make the neck hole big enough for the head.
11. Mark the points 4in (10cm) down the centre line and cut off two triangles so that the front of the neck is lower than the back (see diagram).
12. Cut out. Join the side seams and hem the sleeves.

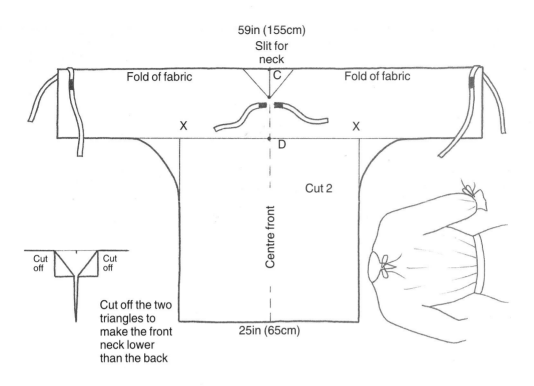

Pattern for shirt 1.

13. Stitch 18in (45cm) of tape at the wrist as illustrated.
14. Finish the slit (page 56). You may want to round the neck hole to sit closely to the neck.
15. Finish the neck with neat zigzag or bias binding.
16. If you are going to add a collar, cut two 4in (10cm) strips cut on the bias and the same length as the neck hole plus 3in (8cm). Seam round the two short edges and one long edge to make a bag. Trim, turn and press and attach to the neck.

When cutting this tunic you may have to join the material, either down the centre front and back or on the end of the sleeves, to make it wide enough for the wrist-to-wrist measurement.

Necklines

It is easy to cut necks too big. Be wary about cutting too much before the fitting until you are used to how many inches it takes to travel round a circle.

Shirt 2

This peasant blouse is another T-shape but much wider and shaped by elastic. It is best made in a very lightweight cloth such as muslin or fine lawn. If the cloth you use is less than 60in (152cm), you will have to join it to get the necessary width.

Shirt 2.

Measure the length from the nape of the neck to finished length. This is the height of the stem of the 'T'. You will need twice this length plus 12in (30cm) of material wide enough for the blouse. 60in (150cm) is the minimum width if you do not have a join centre, front and back.

The length of the cross of the 'T' is determined by the width of the fabric – in this case 72in (182cm) from selvedge to selvedge. Two 36in (91cm) widths have been joined centre front and back to achieve the desired width.

1. Fold the cloth in half lengthways and then in half again widthways.
2. Draw the pattern on the cloth, notching seams.
3. Cut it out. Be sure to notch the top and bottom of the fold as these markers will become useful guides when you attach the elastic.
4. Join the side seams.
5. Finish the sleeve, neck and hem edges with zigzag, a small hem or binding.
6. Bind the neck and thread with 36in

Pattern for shirt 2.

(91cm) of very narrow elastic, or cut 36in (91cm) of very narrow elastic, join it into a circle and mark it in quarters. Mark the neck in quarters. Match the marks on the elastic with the marks on the neck of the blouse and zigzag over the elastic, stretching it as you go (*see* page 57). If you sew it an inch or so in from the edge it will make a frill.

7. Elasticate the sleeve ends to the upper arm measurement in the same way.
8. Try the blouse on with a belt on top. You will see that you can pull the blouse down through the belt (or below a tight bodice) to adjust the neckline.

When you have made the first blouse you will see how you can adjust the width, length and fullness of sleeve as much as you like for different effects.

SKIRTS

Skirt 1

To make the simplest skirt, take a strip of material, sew it into a tube and gather it round the waist with elastic. This is not very adaptable or flattering, but it can be useful and is very easy. The same principle can be used to make a skirt, gathered or pleated on to a waistband large enough to go over the hips, and threaded with elastic to draw it in to fit the waist. This produces a much more flattering and successful effect, as there is less bulk to gather and is well worth the extra time and trouble.

Drawing a pattern on to the cloth.

Skirt 2

Cut a circle of cloth using a tape or ruler as a giant compass. Cut a smaller circle within it for the waist and a 7in (18cm) slit to allow you to pull it over the hips. Use cloth such as cotton jersey, which does not fray, so that you do not have to hem it. This is an easy and most adaptable skirt pattern. As soon as you try it out and can play with the real skirt in front of a mirror, you will see how, depending on the radius of the circles, the same principle can be used for cloaks, capes, head-dresses, aprons, robes and tunics.

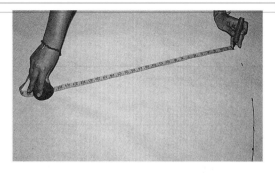

Marking a circle on the cloth using a weight and a tape measure as a giant compass.

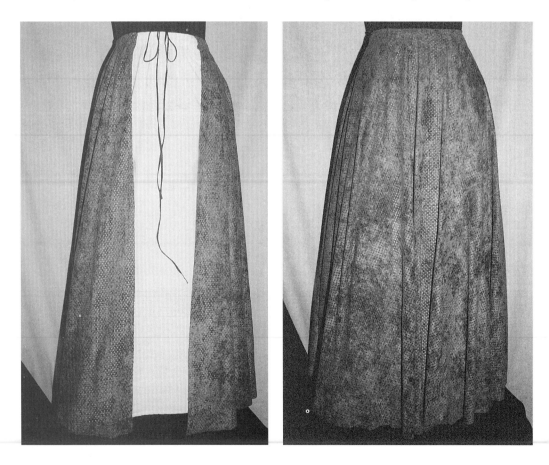

A skirt made of two semicircles tied like aprons. One is tied at the front and the other is put on over it and tied at the back.

A cloak made from a circle folded off-centre and decorated with appliqué. Photo: Hannah Bicât.

If you cut the waist large enough to slide over the hips and gather it with elastic, you will not have to cut the slit and make a fastening.

Finish the waist with any of the waistband suggestions on pages 53 and 54.

Choosing the Radius

To find the approximate radius of a circle, divide the circumference by six. For example, if the waist measurement you want to encircle is 24in or 60cm, the radius of the circle you would need to draw would be 4in or 10cm, or if the hat brim was the result of a $5\frac{1}{2}$in (14cm) radius circle you would need about 84cm (14×6cm) of binding to go round the brim.

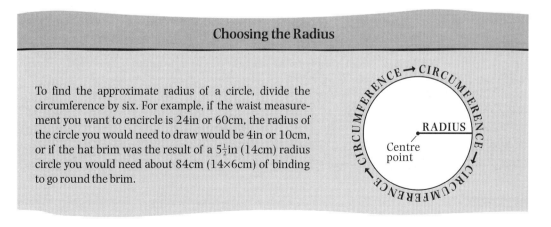

Skirt 3

With train or extra fullness at the back. Use cloth at least 60in (152cm) wide.

1. Double the waist to hem measurement and add 30in (75cm). This is the minimum amount of cloth you will need. Join on more widths for a fuller skirt.
2. Cut the centre front seam on the straight grain of the fabric.
3. Measure the length of the skirt plus turning allowance from hem to waist, starting at the bottom.
4. Draw the curve for the waist as shown on the diagram.
5. Draw and cut the rest of the pattern.
6. Join the centre back seam leaving an opening at the waist so that it will go on over the hips when finished.
7. Finish the waist with binding. Use the tape method of gathering and fastening on page 61, diagram 2, or gather or pleat the fullness into a waistband keeping the fullness at the back.
8. Put the skirt on and mark the hem, leaving it longer at the back for a train or bustle.

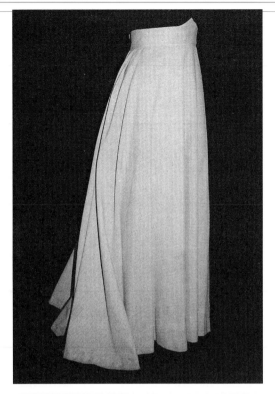

Skirt 3 with a stiffened waistband.

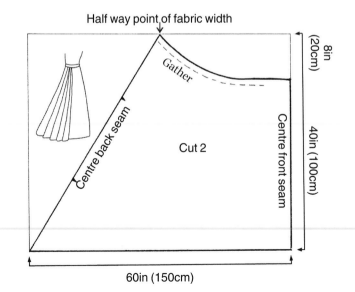

Pattern for skirt 3.

Using Patterns

The pattern library

Collect a library of both commercial patterns and those you cut yourself. Patterns are expensive if you choose from a catalogue and buy them from a shop, but most charity shops and car-boot sales have them, so pick through and select anything that might be useful. Keep a bookshelf reserved for patterns, and work out a way of classifying them so that it is easy to find what you want and see what is missing. A simple start is to divide them into categories such as male, female, child, underwear, and accessories. As the library grows you can subdivide into size, period, or usefulness for waists, lapels and so on.

You may get hooked on your pattern collection and it may end up covering many decades, so try to date the patterns if you can. You can sometimes do this from the copyright information on the instruction sheet. You will find you use favourite patterns frequently, so it is worth storing them in stronger and bigger envelopes than the small and flimsy ones in which they are sold. You can glue the picture on the front and will have space to keep a record of adaptations and information. You will also have room in the envelope to store copies of additions and adaptations.

Older friends or relations may have patterns from the past, which they have kept but no longer need. Always look out for patterns where there is a tradition of wearing national costume or dancing in costume. Shops specializing in dancewear may have a range of unusual and useful patterns.

When you are choosing a pattern, look carefully at the design you are aiming to reproduce and match the two as well as you can. The most useful points are the shoulders, the collar and lapels, the seam positions, the fit over the bust, the sleeve seams, and the way a bodice joins on to the skirt in a dress. The length, fullness and shape of the skirt, sleeves, and the lower edge of the jacket are easily adjusted. So are minor decorations like pockets and collar shape.

Basic patterns

There are some particularly useful patterns which should form the basis of your collection. These patterns will give you a good start and after a few trials you will be able to adapt them to most styles.

Women
A size twelve pattern is the most useful and can be scaled up or down. You may find it easier to use a larger sized pattern for a very large-busted woman.

- A high-necked, reasonably close-fitting woman's blouse with long sleeves and cuffs. When you choose this pattern, make sure the sleeve seams fall on the natural shoulder line and are not set below it. The shoulder seam should lie along the top of the shoulder and it should not have a yoke.
- A plain A-line skirt set on a waistband.
- A pair of trousers set on a waistband that fit neatly at the crutch.
- A fitted, buttoned jacket with a collar and lapels, and a sleeve with the pattern for the upper and lower sleeve cut separately.
- A dress or top, fitted to the bust, with seams each side of the front rather than darts.
- A wedding dress or similar pattern with a pointed waist, sleeves and a full skirt. The bodice should be shaped with seams rather than darts.

Men
A size 40in (100cm) chest pattern is the most useful.

- A jacket with lapels, and a sleeve with the upper and lower sleeve cut in two pieces.

- A waistcoat.
- Traditional pyjamas with a collar and button front.

Choosing the right pattern for the job

Look at the design, note the following points and see how closely they coincide with the design.

Check:

- The neckline
- The shoulder line
- The fit at bust/chest, waist and hip
- Does it have a collar or cuffs?
- Are the sleeves fitted to the actual shoulder or are they dropped a little down the arm?
- Is the bodice close fitting or loose?
- Are the darts or seams that shape the cloth over the bust right for your design?
- Are the trousers or is the skirt fitted or loose?

These are the most difficult bits of pattern cutting, so try to choose one from your collection that is the best match for these points. Remember that the illustration on the pattern of the completed garment may not look at all like your idea. You are using only the information you need and can ignore the rest. Find a size that is close to the one you need.

You may use just the shoulders and bust darts from a pattern and make up the rest. The

Using Dressmakers' Patterns

The picture on the front of a pattern envelope will give you an idea of the shape. The diagrams on the back may give a clearer, simplified picture of the detail and placing of the seams. You will rarely have a pattern that matches your design exactly and will have to pick and choose and adapt to get the shape you need.

pattern for a wedding dress may have just the pointed front you want and will have the slant of the skirt's waist worked out to fit on to it, which will save you wrestling with the problem. It will be an easy matter to make the skirt fuller or narrower and to change the size and shape of bodice and sleeves.

Altering a pattern

If you are not interested in keeping a pattern collection, you can cut the actual pattern and insert or cut out the alterations, re-attaching the pieces with pins or sticky tape. Otherwise, re-draw on to paper or old sheets so that you can keep the altered pattern to use again. You will gradually build a collection of patterns that you find particularly useful and will use them over and over again.

6 FITTINGS

It may seem rather excessive to devote a whole chapter to fittings: it sounds such a simple matter of pins and snipping. But do not underestimate the importance of these occasions to the actor, designer and maker. What happens at fittings has a powerful, though usually unseen, influence on the production. The rehearsal period is never long enough, and fittings need to be carefully planned if everyone involved is to make successful use of the time. In this chapter we will imagine that you, as a maker, are organizing the fitting, though in a larger company it may well be the costume supervisor or some other member of the wardrobe staff who is in charge.

- To the designer, the fitting is a time when she can see her ideas beginning to take shape on the actor. She can see whether the maker is managing to transpose ideas from the drawing, and be reassured that her ideas have jumped successfully from page to reality.
- For the maker, it gives reassurance that the work is faithful to the designer's concept, that the fit and look are correct, and that the actor is happy.
- For the actor, it gives the opportunity to feel the shape and weight of the cloth on his body. He will see himself reflected in the mirror and imagine how he will appear to the audience. He should have the opportunity to say what he feels about the costume.

This may sound relatively straightforward but it is a minefield, and sensitive footwork may be required not to detonate potential explosions.

An actor sees himself in costume at a fitting.

THE DESIGNER AT THE FITTING

The designer will have a precise picture in her mind and have presented it in her drawing. She may, however, have had to work on that drawing without meeting the actor or having any idea of the actor's looks and build, let alone his temperament.

As the maker, you may see the actor in rehearsal before the designer, and if you think something in his appearance may marry sadly with the costume, it is a good idea to warn the designer of this before the fitting. If an actor is particularly unsure about the costume design, it would also be a good idea to mention this to the designer. The more problems that can be solved at an early stage, the better for time, tempers and budget.

A dancer checks her freedom of movement in a costume at the final fitting.

Most designers come to fittings and check the progress of the work. It is good for the maker if they come to a fitting quite close to the beginning of the making process, as well as when the costume is nearly complete. You will be able to ask any questions and sort out any restructuring of the basic shape at the pins and tacking stage, rather than the stitched and braided state, which may save you wasted time and cloth later. The designer can point out anything she does not like, and a solution or compromise can be found, and usually found relatively easily in these early stages.

If designers will be only at one fitting, it is usually the final one when the costume is nearly complete. They will be able to decide on the placing of decoration or buttons, choose the drape of the skirt or the length of a coat and approve shoes or other accessories.

It is unfortunate when, as sometimes happens, designers do not see the costume throughout the entire making process, and their first sight of it is on the actor at the dress parade, or worse still, at the dress rehearsal. There may be no time or money left, and it may be impossible to rectify mistakes and misunderstandings at such a late stage.

When this happens, both designer and maker can be miserably disappointed, but it is best to keep the whole thing as quiet as possible or the actor may lose confidence in the costume. Good communication between designer and maker as the work progresses should make sure this sad state of affairs does not arise.

THE MAKER AT THE FITTING

As a maker, you will be at all the fittings and will often be working alone with the actor. If you are designing as well as making the costume, your job is fairly straightforward. It is a question of making sure that what you see on the actor is what you have seen in your

Working on the attachment of stilts. Note the kneepads provided for safety in rehearsal.
Photo: Hannah Bicât

mind and in your drawings. You will be able to make changes and adjustments without too many consultations, though you should discuss any major changes with the director. Small changes, which can make a great difference to the actor's contentment, can be made without fuss.

When making to someone else's design, you can suggest, but not decide. If the actor is unhappy with the costume, you can put forward possible alternatives but it is best to keep them practical rather than artistic. It is not your job to redesign the costume, however

much you may want to. After you have worked with the same designer on a few projects, you will know when to speak up and when to keep a discreet silence.

THE ACTOR AT THE FITTING

Very few, if any, actors are indifferent to their costumes. Fittings are an important part of their job. It is rarely vanity that makes actors look so minutely at themselves in the wardrobe mirror – it is their job. They have to know what the audience will see, and feel confident that their reflection shows the character they are creating in rehearsals. When actors stop worrying about their costumes, when they know that pockets and fastenings are the right size and convenient to use, when their shoes fit and make the right sound, when their bottoms don't look big and their legs don't look skinny (unless they are supposed to), when they feel confident and right – then you know you have done a good job of work.

This business of 'feeling right' is the tricky bit, as neither you nor they can be more precise. It may be the feeling of a starched cravat high round the neck, the cocky tilt of a hat, the clasp of a corset to the waist, the droop of the sad pockets of a worn cardigan. Whatever the reason, if you are unhurried and observant you will see and feel the moment when actors find something in the mirror or some feeling in the costume that keys precisely with their character. This is the moment when you will be able to begin the conversation that makes a costume the combined creation of the designer, maker and actor. If you judge this moment rightly, it will make a great difference to the creative power of the actors, the ease of technical and dress rehearsals and the contentment of the company. If you doubt for one moment the importance of 'feeling right', ask any actor. Creating this feeling, this lift of confidence, is one of the most interesting,

93

Ascertaining the best length for puppet strings with the actor. Photo: Hannah Bicât

that they are one part of a large picture. It is good to make the cast's visits to the wardrobe enjoyable. When you are approachable and appear unhurried and calm, ideas will flow easily and without tension.

PREPARING FOR THE FITTING

Arranging fittings

Find out from the production manager at the start of the job how fittings will be arranged. Sometimes actors cannot have fittings after, or in breaks from, rehearsal as this would involve overtime pay, which may not have been included in the production budget. When an actor is needed for a fitting, the wardrobe department usually tells the stage manager who will arrange a time that fits in with the director's rehearsal schedule. It will help if you can give an idea of how long the actor will be needed in the wardrobe and consequently not available to rehearse.

It is sometimes necessary to be rather direct, and explain that the costume may not be ready in time if the actor is not made available for fittings. It can be hard to free actors from rehearsal, particularly if they are on stage a lot during the play, but it will also be hard at the dress rehearsal if the costume doesn't fit and the actor is unable to draw his sword without ripping his shoulder seams. Try to be as helpful as you can reasonably manage to be, and engage the stage manager as your ally when there are problems. These are much less likely to occur if you are well organized before your fittings, and have judged the timing of them well.

In a small and less formal company, it works well to put a daily list on the company notice-board of the people you need to see, and for approximately how long you will need to see them – or even mention it in the pub at lunchtime. The actors can then drop into the wardrobe when they are free. Always check

rewarding, creative and inexplicable aspects of your job. You will know when you have got it right.

However, this is not at all the same thing as allowing yourself to be bullied into work that goes against the design of the show. Try to keep in the back of your mind, as well as displayed for all to see, pictures of how the whole company will look on stage together. Stage actors can never see themselves in this situation and they may need to be reminded

with the stage manager if you hope to work like this, and remember that a musical director or choreographer may also be trying to snatch free moments of actors' time as well.

Some actors are endlessly obliging about giving their free time for fittings and, though their goodwill can be a great help, it should not be taken for granted. Others will feel happier with a more formal approach made through the stage manager.

Equipment

Take some time before the fitting to organize your mind and equipment. You will often want tape, elastic and other bits and pieces, but here is a list of the most essential equipment.

You will need, (but may not always get):

- The design
- Full-length mirror
- Enough light
- A warm room for someone who has to stand still for a long time wearing very little.
- A chair or stool. People need to be able to try sitting in the costume.
- Space for the actor to stand back from the mirror.
- Pins
- Scissors
- Tape measure
- Marking chalk
- Notebook and pencil
- Safety pins, a pair of clip-on braces, a hairband and a yardstick or metre rule are used so often that they should always be readily to hand.
- As many of the accessories that will be used in performance as possible should be available at early fittings. It is helpful for actors to know the sort of handkerchief they will be flourishing and the shape of bag they will be carrying on the first night, even though in rehearsal they may be using a Kleenex and a carrier bag.

An actor given space and time to play with the movement of a cloak at a final fitting.
Photo: Robin Cottrell

Make sure all the parts of the costume you need are ready so that you don't have to waste time looking for them or pinning them together during the fitting. You should also know of any action in the play that will require particular flexibility in the costume. You can cut the neatest eighteenth-century coat, but disaster will strike at the technical rehearsal if you hadn't found out that the dashing chap had to swing from the rafters when wearing it, and couldn't get his arms above his head. This sort of information does not always filter through to the cutter of the coat. Always ask actors if there is anything they have rehearsed that might be hampered by the costume.

Underclothes

Underclothes may affect the silhouette of a costume.

- Ask women if they are wearing the sort of bra they will wear in performance, as this can make a considerable difference to the fit of a bodice. Advise and provide a different bra if the period demands it. The fashion for bosom shape changes throughout the post-corset decades. Think of the difference between the boyish flattener of the 1920s, the high-pointed line of the 1950s and the fashionable bosom of today.
- Always do the fitting over the right corset if one is to be worn.
- Remember that the line of knickers under a costume onstage will show up even more distinctly under the lights, and can be seen on men as well as women.
- Items such as petticoats, crinolines and shoes, similar to the ones that will be worn, should be available as they may alter both the hang and the length of the skirt.
- Some white underwear will glow through all clothing under ultraviolet light. In this case, use black to avoid embarrassment at the dress rehearsal.
- Men's boxer shorts are a horror of wrinkles under tight breeches or trousers and laughable under tights.
- Men should usually wear jock straps or dance supports under any garment that is cut with a tight-fitting crutch.
- Do not mark the trouser length until the actor is wearing the correct shoes.
- Be sure not to forget socks or stockings, and the garters or suspenders to keep them up.
- If padding is to be worn, it should be there for the first fitting.
- Tights, particularly on men, sometimes look neater and are more comfortable on elastic braces than on an elastic or drawstring waist.

FITTING THE COSTUME

Sometimes, when the design is difficult to cut, you may be fitting a pattern that you have cut in cheap material, rather than the real thing. This is called a *toile*. On the other hand, you may be fitting a ready-made dress bought in a shop.

In all cases your objects at fittings are:

- To make sure that everything fits well and will look like the design when finished.
- To ascertain the length of trousers, skirt, jacket, bodice, sleeves and so on.
- To make sure the actor can move in the costume.
- To give the actor and designer a clear idea of your intentions for further work on the costume.
- To give yourself a clear idea of what further work is needed to complete the costume.

The top half

1. Try the top without the sleeves.
2. Pin the fastening together in the correct place for the style.
3. Adjust the fit and position of the darts or seams.
4. Make sure the fit under the arms is neither too close nor too baggy.

Movement in Costume

If an actor can squat in a costume with his knees apart and together, bend his elbows and raise his arms above his head and to the front, and stretch both arms sideways at shoulder level, you can feel fairly sure that the costume will not restrict movement onstage. This extreme flexibility of movement may not always be necessary.

An inside-out trial for a dancer's trousers being fitted to allow for specific movement. The result will be dismantled and used as a pattern.

5. Do not hesitate to unpin shoulder seams and re-pin them completely differently to get rid of wrinkles and bags.
6. Draw, with pencil or chalk, the correct line for neck and armholes. Take care not to make the front of the neck too high or tight. Actors hate it and singers panic.
7. Tie a tape or elastic round the natural waist and mark its position.
8. Mark finished length.
9. Slip on one sleeve, pin at the shoulder, and check for fit, length and fullness.

Skirts
1. Put on and pin fastening.
2. Check waist fit and adjust if necessary.
3. Check fullness and adjust if necessary.
4. If using a separate waistband, fit and mark position of fastenings. If it is an elasticized waist, check the length of the elastic to allow the right stretch.
5. Mark the length roughly. It is best to set the final length when the skirt is more complete.

Trousers, shorts, pantaloons and breeches
1. Put on and pin fastening.
2. Adjust fit of the waist.
3. Tie elastic tightly round the natural waist.
4. Pull spare fabric (if any) through the elastic until the crutch of the trousers is in the right place.

97

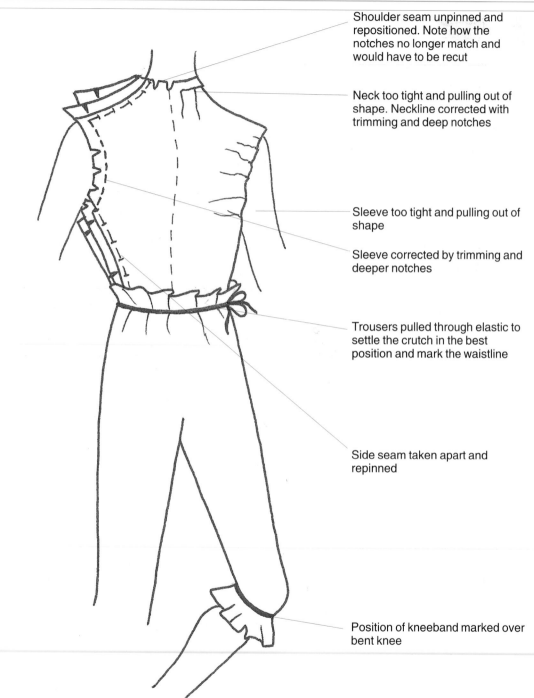

Shoulder seam unpinned and repositioned. Note how the notches no longer match and would have to be recut

Neck too tight and pulling out of shape. Neckline corrected with trimming and deep notches

Sleeve too tight and pulling out of shape

Sleeve corrected by trimming and deeper notches

Trousers pulled through elastic to settle the crutch in the best position and mark the waistline

Side seam taken apart and repinned

Position of kneeband marked over bent knee

Fitting techniques.

5. Check fullness and adjust if necessary.
6. Check waistband, kneebands and ankle bands, and mark position of fastenings.
7. Mark the length roughly and adjust when the trousers are more complete.

Shoes

1. Make sure they are comfortable.
2. Make sure they do not slip on the stage.
3. Use innersoles and heel grips if necessary.
4. Check the actor can jump, run, dance or do whatever he has to in the shoes.

Slipping Shoes

To stop shoes slipping, score leather soles in a lattice pattern with a sharp point or stick on rubber soles. A quick emergency measure when an actor is in danger of slipping during a dress rehearsal or performance is to spray the soles with 'Spraymount', a glue that is used for mounting artwork or photographs. You can do this in the wings while the shoes are on the feet.

Hats

1. Check for comfort.
2. Make sure they are secure.
3. Check length for elastic, ribbons and so on.
4. Provide hatpins – long pins with a decorative bobble on the end. They go through the hat, through the hair and out through the hat again. If the hat still slips about, try putting a pin-curl in the hair with grips and securing through that. You can buy 2in (5cm) combs to sew in the front of hats. They will grip the hair and stop the hat slipping backwards. They can be used invisibly on the smallest hat.

5. Make sure the brim will not screen the actor's face from the audience.
6. Remember that a hat brim must not keep the light off an actor's face.
7. Fit hats over a wig if one is to be worn.

DRESSING AND UNDRESSING ONSTAGE

Another minefield requiring tact, planning and discussion. Onstage nudity sounds an easy, economical option for the costume department. But, oh dear, no! Actor after actor will drop in to the wardrobe asking for a bit of muslin drape, worrying about how to get their clothes on or off without looking ridiculous, and asking if they are too hairy or not hairy enough. And rightly so – any dressing or undressing, total or partial, that happens in view of the audience needs to be planned and performed with confidence. It is so easy to look funny or clumsy by mistake, or not funny or slick enough when your trousers have to fall down on cue. Remember that though some people can wander about stark naked or in underwear without any embarrassment, others find it one of the most difficult aspects of their job. Be tactful and helpful. Try to provide as much privacy as possible and judge carefully whether a humorous or discreet attitude will be better.

QUICK CHANGES

If actors have quick changes to cope with during the play, you must consider this at an early fitting. The best road to a good, quick change is practice. And calm. Find out how quick the change must be, finish the costume as early as possible, and rehearse it quietly in the wardrobe with the actor and a stopwatch. It is a very bad idea for the first try-out of the change to happen in the busy tension of a dress rehearsal. Everyone around will produce

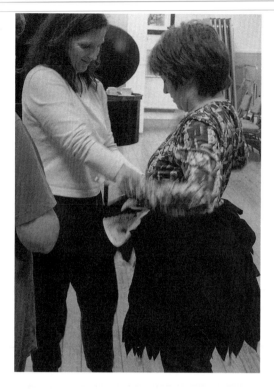

ABOVE: *Waistcoat, shirt and tie made to fasten in one at the back for a quick change.*

LEFT: *Experimenting with an onstage quick change in rehearsal. Photo: Hannah Bicât*

Space made in the prompt corner for a quick change. Photo: Hannah Bicât

some suggestion to speed things up and the actors involved will be surrounded by distraction and worry at the very moment when they most need steady confidence.

The first time it may be agonizingly slow, but once the order of taking off and putting on garments has been learnt, it will speed up. Work out where you must hang or place garments for the greatest speed, and talk to the stage manager about how to arrange this. Sometimes, very quick changes take place in the wings, and the space must be clear for this to happen. There may need to be a mirror and light if there is a make-up change. Check the space before the first rehearsal of the change to make sure it is suitable, and to avoid the costume being damaged or torn on a nail so near the first night.

Talk to actors about where they would like fastenings and the sort of fastenings they

Quick Change Fastenings

Men are used to clothes fastening with the left over the right side and women vice versa. There will be less fumbling if you stick to this where possible when making quick-change costumes, even with cross-dressing (men dressing as women and women as men).

prefer. Many actors like quick-change fastenings at the front so they can fasten them themselves, others prefer to rely on a dresser. Listen to them. They are the ones who will have to go onstage when their cue comes, ready or not.

7 BASIC COSTUME

The basic costume is often the best, and sometimes the only way to costume a play when working to a small budget. Film and television have made today's audiences familiar with historical fashion. A small company might not want, and certainly would not be able to create so accurate a picture – the wig alone might absorb the budget for the whole costume. Although a company may be financially impoverished, it can be rich in imagination. It can harness the familiarity with period costume that the high-budget film has given the audience, and use small signs to create a picture of a period. The

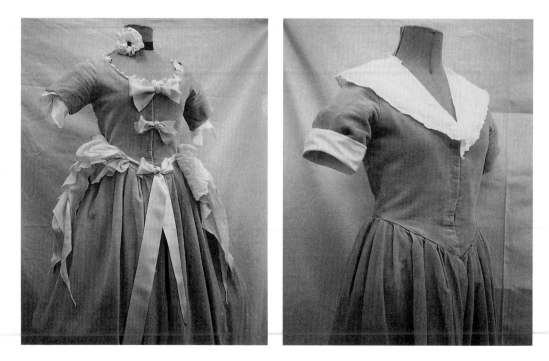

The same dress made in dyed flannelette sheeting from a wedding dress pattern with additions of collar, cuffs and petticoat to change it.

basic costume suggests rather than imitates a time and has many advantages. If you work regularly with the same company, you can gradually build a collection of costumes that will adapt easily. This will free money from the budget that can be used to buy better accessories.

The secret of making this method work is for the basic costume to be functional and non-specific in colour and texture. You are trying to make the audience ignore the basic costume. Do not be tempted to use opulent-looking cloth for the king or a rough cloth for the lowly peasant. Avoid anything shiny or bright in the base colour, as it will detract from the detail you add – a showy background will take away the clarity of the information you hope to impart with the belts, hats, gloves, collars and so on.

You are using the audience's imagination to paint between the markers you give them. Pinpoint the period you want to suggest through the use of a few precise accessories. The selection of these accessories is most important. Careful research of the period and play, and discussion with the director about the style of performance will help you to the right choices.

Imagine the lord and the goatherd. They stand before the audience in exactly the same trousers and shirt. The lord has his shirt settled smoothly into his trousers. He wears a wide, ornate belt with an elegant buckle, and a bejewelled dagger. He has a neat ruff at his neck. His trousers are tucked into kneeboots and he wears leather gauntlets. His hair, cleanliness and the smooth hang of his well-pressed clothes hint at the valet in the

background. Now look at the goatherd – he has the same clothes, but crumpled. His collar is undone and his sleeves rolled up. From the skin of one of his goats he has made a rough, sleeveless jerkin, which is bunched round his waist with an old leather belt. He has bare feet or rough shoes.

The audience will be in no doubt as to which is which. The picture will have been painted without a complete costume. The imagination of everyone in the audience will have had a hand in the painting, and therefore they will find it easy to believe in the picture.

Of course, this is a very obvious contrast. When it comes to a group of lords or goatherds you must be more subtle. This is easy enough if you remember the differences you noted at the railway station in Chapter 1. These differences existed in the past as surely as they do today, and the behaviour of humans has not changed that much – their clothes still reflect their personality.

Imagine five lords at court. They are all in the same basic costume, but perhaps:

- Lord Debonair sports a heavy brocade short cloak over one shoulder with thick gold cord ties.
- Lord Royal wears a narrow, flat band of gold round his head and has gold embroidery round the angular cuffs of his gloves.
- Lord Intellectual has spectacles and wears his ruff with the tapes undone.
- Lord Dodderer has a paunch, a stick and a grey beard.
- Lord Princeling wears his shirt as a tunic, belted over his trousers with narrow gold and scarlet. His hair curls round his collar. He wears shoes instead of boots.

These details, together with the playwright's, director's and actor's skills will create the character. Never underestimate the audience's ability to interpret costume, or the actor's ability to make them understand the status, the relative situation and the personality of the character. The clean, uncluttered lines of your basic costume will provide a background that will throw the detail into sharp and exciting relief.

Research the period so that you are familiar with the appropriate fashions. Talk to the director and ascertain the style of performance. This is not always as easy as it sounds. In textbooks, genre is divided into compartments with neat labels such as naturalistic, post-modern, Brechtian and so on. In reality, the boundaries are blurred and styles overlap and merge. You have to find a way of translating the cerebral, as well as the emotional, demands of director and script into shoes and handbags.

Appropriate Footwear

Remember that a basic costume includes footwear, and any style of shoe or boot that is not worn by everyone will seem to make a particular statement about the character. Suggest to actors that they wear shoes or slippers in the wings for safety when they are barefoot onstage.

DECIDING ON THE STYLE OF THE BASIC COSTUME

Footwear

Shoes are often a safe place to start. For some reason, possibly because everyone minds so much if their feet are uncomfortable, it is easy to talk about shoes, and this topic of conversation will often prove the gateway to

understanding the director's vision and helping him to visualize yours. It can also be a useful way of marrying dreams and academic concepts to the practicality of a costume that must be worn and worked in by an actor. Not every vision can withstand the rigours of sweat, the washing machine and a dwindling budget, but a costume must, or it is a failure.

Try the following questions:

• What sort of movement or dancing does the director envisage?
• Should the shoes make a noise?
• Should the shoes have low, medium or high heels?
• Should the actors wear shoes at all, or should they be barefoot?

The answers to these questions, but more particularly the conversation it will ignite, will lay a baseline for your standardized costume.

• The movement may demand rubber soles and flexible, lightweight shoes or a character shoe with a heel suitable for a formal minuet.
• The march of battle may require a heavy boot with a crunching heel.
• Bare feet, though a nightmare for the stage manager who must make sure the stage and the wings are free from splinters, have particular advantages. Bare feet on a character who would usually wear shoes, (imagine a formally suited gentleman with bare feet) are a signal to the audience that the costume is representative, and not realistic, and that they must fill in the details from their own imaginations. In this situation, the addition to the costume of a boot or a shoe makes a strong impression on both audience and actor. The other great advantage is that bare feet are cheap, most people have them and they fit!

Colour

The colour and texture of the basic costume must be decided through conversation with the set designer. The colour you choose must look right against the colour of the set and prove an appropriate background for the accessories you will add where necessary. It must also, of course, fit with the feeling of the script. It would not help the play much if the actors in a high tragedy were all in pale yellow, or those in a light comedy in dark brown. Black, white, cream, beige or grey are the most useful colours as they provide a relatively neutral background. Some plays may demand a more vibrant colour range but with a basic costume this is exceptional. An alternative method is to use a standard shape in different colours.

Choose cloth by texture and practicality as well as colour. Calico, cotton, wool or a linen-type mixed fibre cloth are useful materials. There are also some excellent mixed fibre or cotton jersey cloths, which have the advantage of draping in flowing folds and often do not need hemming. On a circular full-length cloak with a circumference of perhaps ten yards or metres, this can save hours of rather dreary labour. It is sensible that the cloth should be washable and should not crease easily.

Style and shape

The first decision is how strongly to suggest the period. Should the women wear long skirts if they were worn in the period of the play? How will you suggest battledress or uniforms through your basic costume? How can you suggest the formality of suits without actually using them? Here is a list of a few rather prosaic basic costume suggestions that might be helpful in sparking ideas. The script will spark off more interesting ones.

• Everything, shoes and all, one colour, but

Adults playing little boys with additions of collars and caps to their basic costume.
Photo: Robin Cottrell

each character in clothes appropriate to their role.

- Each character in a single colour appropriate to their role. The uniformity is achieved through the separate blocks of colour.
- Each character in exactly the same top and trousers with long skirts on top for the women when occasion demands.
- White leotards or close-fitting T-shirts with long black skirts for women, black trousers and white shirts for men.
- Waistcoats (cheaper and easier to buy, make or fit than jackets) over white, black or coloured shirts.

Hats, hair and make-up

Imagine a group of actors of differing ages, sizes and colouring. Put them all in identical, mirrored sunglasses or bowler hats or scarlet

lipstick and they instantly give the impression of having a joint identity. If you take one from each group and look at them as a trio, the difference between them is most clearly stated. And stated with speed, economy and clarity. Once you have seen how this works, you will be able to invent innumerable and more subtle ways of leading the audience's imagination to follow the script and the director's path. Study the shapes of the hairstyles and make-up of the period to find a simple way to suggest this, paying particular attention to the silhouette. It may be as simple as the difference between centre-parted hair and a bun low on the neck and all the hair swept up into a loose bun on top of the head. Or a greased head of hair tousled or sleek.

8 ACCESSORIES

Every time you read a novel from a bygone era, fascinating nuggets of information crop up, and the opportunities for researching accessories seem endless. The rules of society which governed the use of these small additions to costume, provide rules for the wardrobe department about who should wear what where and when. In the 1930s it was quite eccentric for anyone to go out without a hat, and no man in English society who was not an artist or a cad would have worn brown shoes in London. Who would know that if they had not read it in a novel or book of etiquette written at the time? You can be certain someone in the audience does, and if they see it onstage, will be distracted from the play (and probably write a letter of complaint to the management). You will never be able to please the pedants in the audience all the time – the rules are too many and too varied. However, the more you know about these odd rules that governed society in the past, the more likely you are to produce an appropriate costume.

Often it is the snuff handkerchiefs, chatelaines, fans and walking canes that help actors to feel settled in the period, making sense of a comedy of manners or a difficult speech. The complex uses of such accessories are a fascinating study for anyone who enjoys that sort of detailed research.

These time-consuming bits and bobs are usually referred to as costume props. Most of them will be provided by the wardrobe. You should ask the stage manager to let you know if any are worked into the action in rehearsals. These will not be the only ones that are worn, as most costumes, and particularly the more naturalistic ones, require some extra touches. These are just a few ideas for making accessories when you do not have access to specialist equipment and have to make do with what you have to hand.

SHOES

Think back over the last ten years of your lifetime and try to remember the different shoes that have been fashionable, particularly women's shoes, and you will start to get an inkling of how big a subject this is. Think of the shoes other generations are currently wearing, the footwear of other countries and cultures, and how those who wear no shoes protect or decorate their feet. Then there is the practical matter of shoes for different jobs. There are the flexible slippers of the gymnast, which will bend and grip on a rope or trapeze, the extraordinary thigh-high waders of the fisherman, the protective boots of the builder, and the tiny bootees for the soft-boned feet of a baby. You could make a list of hundreds and invent many more. Imagine what people might wear on their feet in the future – judging by the

incredible variety of footwear that has been worn in the past, some would look utterly bizarre and some quite as if they could be worn today.

People have always worn, and will always wear, extremes in footwear. Something in the powerful dictates of fashion leads people to imaginative excesses, which are often impractical and uncomfortable. The trendy young lady in the 1960s forced her poor feet into those narrow-pointed, teetering-heeled stilettos. The lad-about-town in the fourteenth century had such long points on his boots that he had to hitch them to his garters in order not to take a tumble when strutting his stuff in the banqueting hall. And older generations, in their bunion-easing, sensible shoes, probably muttered just as much then as now about the wild fashions of the youth of the day.

Actors mind very much about their shoes. For many of them, finding the right shoes is necessary to the creation of their character. It matters to them that they should feel right, but not always that they should look right. It is your job to make sure they do, and on a small budget this can be a real challenge. Hiring or buying the correct footwear, the easiest option, is often beyond financial limits. You are left with having to adapt shoes or boots that you can buy in jumble or car-boot sales or markets.

For eras preceding the end of the reign of Elizabeth I, this is not too difficult. Most shoes for both men and women can be created out of fabric or leather. You can cut and stitch the shape of the upper part and glue it on to a gym shoe, plimsoll or lightweight canvas shoe. Old suede or leather garments can be made into excellent and hardwearing shoe uppers and

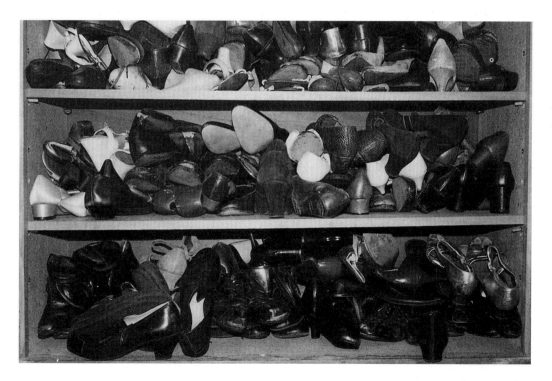

Shoes on the verge of anarchy in the shoe shelves. Rubber bands would help quell the riot!

Cutting and adding suede tops to gym pumps to make short boots.

will not be too tough for the sewing machine to stitch.

To create footwear fashions from later eras, you can add tongues, rosettes, buckles, bows and bootcuffs to today's shoes. Look for ones that are roughly the right shape and weight for the time, which you can then paint, dye, or cover with cloth. Car-spray paint is available in many colours and covers a multitude of alterations and additions. Spray paint,

Bodged boots. With added cuff, with ice skates removed, with added leather top, with front slit and laced, and with fabric upper on karate shoe.

particularly when applied in several thin coats, stays on well and does not crack as much as other paint. It fills the air with its smell, so try to use it outside or in a very well-ventilated room.

Men's boots are often a problem. It sometimes works if you attach new and longer tops to short boots or shoes and paint all the same colour. You can make spats or gaiters to strap over shoes. Boots and shoes are the items where the small-budget worker is most often tormented by the utter impossibility of getting it right.

Wigs

Good, convincing wigs cost money. If you cannot afford a good wig that fits well and suits the purpose, do not use one. Be ingenious with hats and hairpieces. If you see a good wig going cheap, buy it. You can always chop it up and stitch parts of it on to a hat if you cannot use it as it is.

Stylized or comedy wigs are a different matter, and can be made from a wild variety of improbable materials. They will never look realistic, but it will be possible for the audience to take them seriously if the rest of the costume is similarly stylized.

Some suggestions:

- Foam tubing (used for curtain tie-backs and available from curtain-making suppliers). This can be shaped into huge curls, glued and spray-painted.
- Some lycra or jersey-weave cloth will form a tight roll when cut across the width and look like a giant fringe. This can be sewn in layers on to a scull cap to make ground-length Rapunzel or mermaid-type hair or a shorter, thick, clown-like bob. The very cheap panne velvet or old T-shirts are also excellent for this. Wool, raffia, string, piping cord and the like can all be glued or stitched

Cutting cotton jersey to make hair.

Cotton jersey hair on puppet child.

Upholstery fringe as hair on puppet head made of shredded paper pulped with wallpaper paste. Photo: Robin Cottrell

on to a base made from the crown of an old felt hat.
- Buckram, available from soft-furnishing departments or good haberdashers, can be curled or pleated, painted and stitched. It can also be shaped when damp and will dry hard over a mould.
- Long, heavy fringe makes excellent hair.
- It is possible to chop up an inferior wig to make quite convincing hairpieces.
- Cheap hairpieces sold in markets may look dreadful unadorned but will look fine under net or muslin caps and snoods.

Hats

Hats must be one of the most significant objects that humans wear. As such, they are most useful to the costume designer and maker. They are, with a few exceptions such as the bowler hat and the white hunter's pith helmet, relatively cheap and easy to make. The alteration they make to the silhouette of the actor onstage is easily visible to the audience, and will help them place the character in period, profession and class.

The tube hat

This is the same principle as a pull-on knitted hat and the most simple hat of all to make. Highly versatile, it can be made in glowing stretch satin decorated with gold, lace and pearls for a queen, or dishcloth cotton dyed sludge-brown for a convict.

Here are some suggestions:

- Make a tube of material with a slight stretch in it, which will fit snugly round the head. Put it on and tie a piece of narrow elastic to gather the cloth at the crown.
- Make the same again with a longer tube. Put it on and let the tail hang down the back or wind it round the neck like a muffler.
- Slit the tail in half or in three with a bell or bobble on each gathered point like a jester. Stuff the points lightly if you like.
- Pull the tube over the whole head, cut a hole for the face to look through, and slit the bottom part so that it sits on the shoulders. (You may want to insert triangles to cover the shoulders for a cowled hood.)
- Cut the tube in a more conical shape and turn the bottom over some wadding or foam to make a padded roll round the head.
- Leave a long tail on this shape and wind it round the head.

The same shape bonnet in different textured fabrics for the rich and poor.

The felt hat

Useful, easy to find second-hand and very adaptable. Felt hats may look very different but most of them start life in the milliners as a conical-shaped piece of felt, which is steamed into shape and stiffened. Many of them come to rest at car-boot sales, jumble sales or charity shops. You can also find them at sales in the girls' school uniform department when schools have closed down or changed style. Buy or beg a wide-brimmed one for experiment. It is more comfortable to use a hat block – you can use your own head if you have to, but be careful not to burn yourself when stretching the hat.

Here are some suggestions for adapting a felt hat:

- Remove any decoration from the hat and try it on.
- If it is too small, hold it over a steaming kettle and try it on again. You may have to remove the inner band to allow it to stretch enough.
- If it is too big, make a band of ribbon or tape that will fit your head measurement easily. Steam the hat over the kettle, put it on the hat block or head, and jam the circle of tape in place over it. Smooth it down and the hat will shrink to fit.

- To make the brim more floppy, steam the edge and stretch it. You can do this with your fingers or with an iron.
- To make the brim tighter, cut out a triangle like a dart and restitch.
- Trim the edge to a different shape with scissors. Felt does not fray, so you can trim in scallops or other elaborate detail if you want to.
- Pin the brim up onto the crown in different shapes.
- Wire the brim by running some millinery

A round felt hat.

Front and back pinned up and a cockade.

Three sides pinned up for a tricorn.

Two sides up.

One side up and a feather.

With flowers.

wire (or garden or other thin wire) threaded through a bias bound edge.

Variations on the mobcap

1. Cut a piece of cotton 20in (50cm) square.
2. Measure from the centre of the top of the head to the middle of the ear.
3. Draw a circle with a radius of the above measurement in the middle of the cloth.
4. Bias bind on this line to make a channel for elastic. Stitch the outer line of the binding on first. Notice the wobbliness of the bind-

ing. Press thoroughly. Note with delight the ease with which you can now sew the other side! This is a smug reminder to you to press and iron as you go along for a neat easy finish. Leave a little gap in the stitching to thread through. Cut a piece of elastic to fit the head snugly and thread it through the channel. Join the ends securely.

This basic information will enable you to make many hats and caps. If you alter the position of the drawn circle you can make the hat shorter

The mobcap principle used to create different styles.

A simple hood shape cut from doubled fabric.

Hood cut with a separate, circular cowl.
Photo: Hannah Bicât

The second photograph shows the hood put on with the head through the face hole.
The remainder of the hood and the cowl have been tucked and pleated on top.

at the front and longer at the back. Rounding off one, two, three or all four of the corners of the square will give you different shapes of brim. Make it in lace decorated with bows, rough beige linen or crisp starched cotton – whatever you want for the effect you need.

Zigzagging Elastic

It is possible and, with practice, quick, to make a circle of narrow elastic and zigzag over it to hold it in place as you did in Exercise 7. Stretch the elastic as you stitch and make sure you do not catch the needle in it by mistake.

Straw hats

Straw hats are the cheapest hats to buy. Alter the shape of the brim of a straw hat by drawing the shape you want on the hat brim,

then sew on one side of a wide bias binding, trim off the excess straw and stitch the binding over to cover the raw edge. If you cut the straw before stitching the first edge of binding, it may shred and fray too much. You can alter the angle of the brim by cutting triangles out of it and zigzag stitching or gluing it together again. Cover the alterations with flowers or ribbon if you need to.

Making hats

To make a hat with a 4in (10cm) straight crown and a 3in (8cm) brim.

1. Cut and stitch into a circle a band of petersham, belt stiffening or some other sturdy cloth that is 1–1½in (2.5–4cm) wide. It should fit the head rather loosely.
2. Cut a strip 4in (10cm) wide and long enough to go round the outside of the band plus 1in (2.5cm) seam allowance. Join it into a ring for the crown.
3. Heads are oval rather than round in cross-section, so position the band in a slightly

Bonnet made by altering the shape of a modern sun hat.

oval shape on a piece of paper and draw round its outline. This is your pattern for the hole for the head and the 'lid' of the hat. Check it is more or less even by cutting out the shape and folding it in half vertically and then horizontally, and trimming. Make sure this shape still just fits inside the band and has not become too small.

4. Place this on the pattern paper and draw round it.
5. Measuring at right angles from this line, mark an oval $2\frac{1}{2}$in (6cm) outwards for the brim and 1in (2.5cm) inwards to make a flange to attach to the crown.
6. Cut out in a stiffened material.
7. Snip the 1in (2.5cm) allowance at 1in (2.5cm) intervals to the line so that you can bend them up to glue or stitch to the crown.
8. Draw an oval from your pattern for the lid of the hat. Add a 1in (2.5cm) margin all round to glue inside the crown. Cut it out and cut little triangles out of the 1in (2.5cm) allowance so that you can bend them down

and glue or stitch them to the inside of the crown.
9. Use the original circle of petersham to neaten the inside of the hat.

When you have made one of these, you will see how to vary the shape according to need. To make a rounded crown, either use the middle of an old felt hat or make it from four, six or eight curved triangles that when stitched together fit the band.

You can make these hats from felt stiffened with wallpaper paste or PVA adhesive, thin carpet felt underlay, foam rubber covered with cloth, interlined fabric, cardboard, bubble wrap, sacking, thin rubber – anything you think might work. Very wide brims may need to be stiffened with wire round the edge. A high crown to the hat may need the extra rigidity of something like corset bones or cane stop it flopping.

Many useful hat-making supplies, such as pelmet stiffening, foam rubber and interlining

An extra-tall top hat showing the boning on the inside to keep it upright.

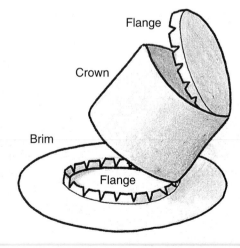

How to put a top hat together.

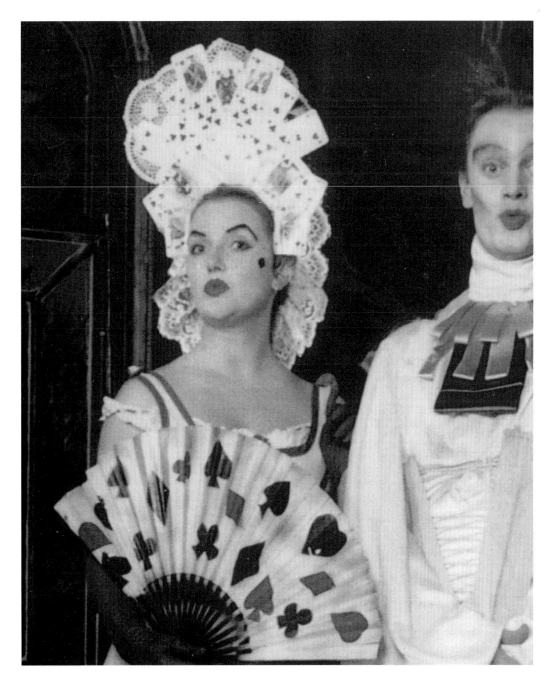

Head-dress made of playing cards and doilies glued on to a hairband. The fan is painted and stencilled with spray paint. Photo: Robin Cottrell

can be found in upholstery shops. If the budget can run to it, there are many specialist materials available including buckram (a glue-impregnated stiff cloth), milliner's net, felt hoods, and special stiffenings.

CROWNS

There is fashion in crowns as there is fashion in hats though it does not change so quickly. It is not hard to research this subject as kings, queens and other crown wearers tend to have had well-documented lives. They leave behind them portraits, photographs and in many cases the actual object. Most crowns are made of precious metal and jewels though some, such as Jesus' crown of thorns, the Roman laurel wreath, and the May Queen's coronet of flowers, have a symbolic value.

The difficulty with stage crowns is to make them convincingly metallic and heavy without being over-cumbersome or gaudy. It is better to simplify rather than elaborate the shape, and try to give an appearance of thickness without adding too much weight.

Here are some suggestions:

- Cut the shape in thin foam. Cover with cloth and stitch detail through the foam. Sewing machines work well as long as the foam is fabric covered. The foam will stretch slightly and cling to the head. When painted with metallic paint and seen under the stage light, the sewing lines look like patterns chased in the metal and can be quite ornate.
- 'Jewels' will look more realistic when set in a surrounding of narrow cord or painted string.
- Outline the edges of the crown with cord, braid or an extra strip of foam to add thickness.
- When painting, be wary of too pristine a layer of gold or silver unless you want a pantomime look.

Crown made of suede-covered foam and decorated with braid, buttons, 'jewels' and painted ermine. Photo: Hannah Bicât.

- Make sure the crown does not look top heavy by adding extra thickness to the band round the base.
- You can usually find something knocking around to make a good base on which to build a crown. Try chopping up old carpet underlay or any thick felt, old leather belts, all sorts of packaging, laminated posters, or lightweight, flexible flooring materials.

APRONS

Although an apron is nothing more than a piece of cloth tied round a body, this simple addition has magical powers in the harsh world of the meagre budget. Aprons are easy to make and fit. They use little material compared to a complete costume and can be made of sacking, muslin, cotton or plastic. They are wonderfully adjustable and can be donned and dropped with ease and decency. They can be bibbed and pocketed, lacy or starchy, decorative or practical. Actors can

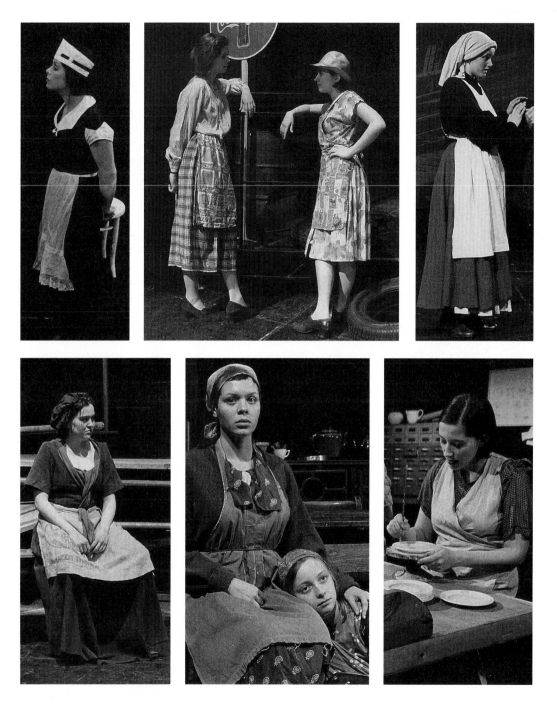

Aprons simply and clearly defining costumes. Photos: Robin Cottrell

show an audience their world and mood and, with the tying of the apron strings, can turn an audience's thoughts from sexy romping to the smell of new bread. Nurture your apron collection.

BELTS AND SASHES

Belts are good pointers to the status of a character. They are also a useful and easy way to alter the fit of a garment without making it look clumsy. You must choose your belt carefully to suit the character. Collect a wide variety, as they take little storage space and are cheap second-hand though expensive when new. Leather belts can be altered easily with scissors, embellished with different buckles, and painted, glued or stencilled with decoration.

Some suggestions:

- Rope, cord and plaited strips of cloth.
- A flat plait of leather or plastic with one strand gold or a contrasting colour.
- Brass curtain rings interwoven with ribbon.
- A strip of cloth or scarf, fringed, wound round and tied in a knot or bow, which can be tied at the side or the back. It could be delicate pastel silk for a Victorian young lady or bright stripes wound round twice and stuck with a sword for the brigand chief.
- Sashes can go over the shoulder, across the chest and hang down one side in a decorative manner. Leather belts can do the same and look military.
- If the belt holds a sword, make sure the sword hangs at the right angle and can be drawn and sheathed easily if necessary. Actors will need to work with this early in rehearsal.

Weapons

Weapons used onstage are usually the responsibility of the stage manager. However, you should know if they are going to be required and make sure the actor can get at the gun in his shoulder holster or draw his sword with a flourish and not with an ignominious fumbling of coat tails.

GLOVES

Many of our ancestors used gloves as much more than a protective or warming device. There are examples throughout history and fiction of gloves being given as favours, offered as bribes, being used as talismans, or to display wealth and delicacy of manner. The etiquette surrounding their use is dazzlingly complex.

Most gloves can be re-created for stage purposes on the base of a modern glove. Gauntlet-style cuffs or decorative edging and decoration can be added. Actors should be able to get gloves on and off easily and have the chance to rehearse with them, particularly if they are handling props when wearing them. White gloves for men can be bought more cheaply from places that supply catering needs than from clothes shops.

MAKE-UP

Make-up must be carefully judged. The size and proximity of the audience and the style of the play must be taken into account. The line of the eyebrows, the eyelashes and the shape of the mouth are the lines that can and should be accentuated – not necessarily altered, but clarified. These are the points that best convey the actor's thoughts to the audience. Make-up

is a difficult skill for actors to master. They have to peer at themselves closely in the dressing room mirror, without the benefit of stage lighting, and imagine what their face will look like from the back of the gallery as well as from the front row. Encouraging a young actor to paint lines on his face to represent age is usually disastrous and unconvincing. It will only work if it is skilfully applied and the face and any visible neck have a suitable silhouette. In smaller venues, make-up should be very subtle unless it is intended to look unnatural.

9 MODERN CLOTHES FOR PERIOD PRODUCTIONS

Look at modern clothes with a fresh eye. Some of them can be adapted to give the picture you need, but choosing them is not always easy. You have to learn to look at clothes as if you have never seen them before and have no preconceptions about them. Concentrate on the silhouette and the feeling the clothes will give the actor. Get the waistline and length in the right place for the period, and the relative proportions of tops, bottoms and sleeves close to reality. Be brave about decorating, cutting away and adding to the garment.

Remember that you are trying to convey the feeling of the play, an impression of the era, and the class and situation of the characters. Adapting modern clothes will only work if all the characters are dressed with the same degree of realism. You must present the audience with a consistent style that they can perceive as reality, and not confuse them by showing one character in full eighteenth-century costume, wig and all, and another in a mocked-up version with a wig made of buckram.

TIGHT BODICES

A perennial problem is the corset or tight-fitting boned bodice, which changes the shape of the body. Look at modern women's tops and try to find that clasping shape. Your first thought may lead you to the bodice of an evening dress, which, perhaps, is already boned and supports the bust in a particular way. But think again, more widely, and many more ideas will come to mind.

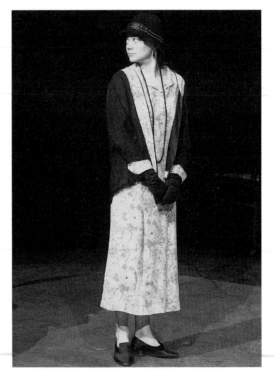

Hat, beads, gloves and shoes emphasize the cut of this costume. Photo: Robin Cottrell

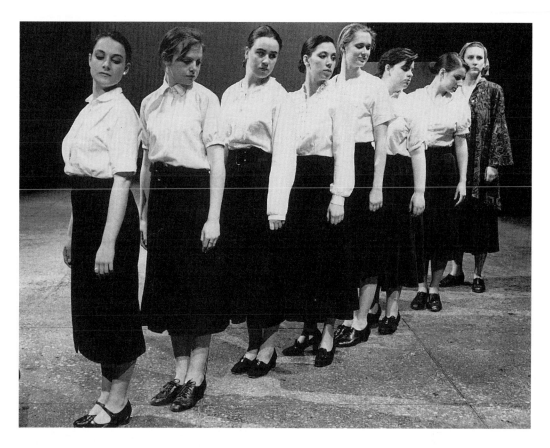

Modern clothes pushed back in time by hairstyle, skirt length and shoes. Photo: Robin Cottrell

Suggestions:

- Tight T-shirts and cotton jersey tops. It is easy to adapt neck and sleeves if you bind them (*see* Chapter 4), cutting off the excess cloth after the first row of stitching. Ghastly stretching will occur if you cut before you stitch.
- Leotards and bodies. The ones in stretch velvet or a wool and lycra mix are particularly useful.
- Fitted women's waistcoats – easy to take in and ready buttoned and buttonholed. You can add sleeves and collars.

- Tight blouses in firm cloth. Alter to fit snugly, bone each side seam, and the front and back if they wrinkle.
- Create a mould on the body with strips of gaffer or masking tape. Work over a thin cloth or an old, light undergarment, which you can use as a lining. Rule and cut an opening through tape and lining, trim off the excess lining and fasten with stick-on velcro. The silver gaffer creates a metallic, armoured look and the masking tape can be painted in any way you like. The effect is unrealistic but sometimes appropriate.

- A firm waistband, stiffened and boned, will help an actress to look and feel corseted.

DRESSES

Modern dresses are most likely to be useful for periods after the 1920s when women began to show their legs.

- Look out for cloth and shapes that suit particular eras, such as the geometric or beaded patterns of the twenties and the square-shouldered cut of the forties.
- Make sure the dresses are long enough.
- Dresses can be cut off and made into blouses, bodices and tunics.
- The skirt of a dress can be cut off and the cloth used to make new sleeves and a collar for the top.
- Look at dresses and see how altering the position of the waistline and hemline will alter the apparent period of the dress.

TROUSERS

Look for.

- Old-fashioned trousers with fly buttons instead of zips. They are often cut higher in the waist and are less likely to gape under waistcoats.
- Trousers with wide legs and turn-ups. Take down the turn-ups, unpick and re-cut the legs. Re-fit to mark the new hem length. Leave the pockets untouched if possible, especially if they are appropriate to the period – actors love pockets. The easiest way to alter the waist is at the centre back or to hitch it up with braces.
- Checked and striped trousers can be re-cut – the legs are easy to alter, the hips more difficult. Try to find the right shaped front so you can avoid having to get rid of unwanted pleats at the waist.

- It was not habitual to wear trousers with a front and back crease until the late nineteenth century, so press the crease out if it is not needed.
- Use braces for men if you can. The trousers are easier to fit, hang better and will stay sitting in the right place and not slip down on to the hips.
- Trousers can be cut below the knee and a band cut from the leftover cloth to transform them into breeches. Mark the place to cut them over the bent knee or they will be too short when the actor sits down.
- It can be difficult to find black, well-cut trousers. Second-hand evening dress trousers may sometimes be found in charity shops, often of good quality and not very worn. You can unpick the satin stripes down the sides.
- Army surplus shops can be a good source of interesting trousers.

WAISTCOATS

These can be a useful way to suggest formal costume. Try to build a collection.

- You can alter a modern waistcoat to the straight-cut one of earlier days by bagging in the points at the bottom, hand stitching them into place and pressing firmly under a damp cloth.
- The shape of the front can be re-cut and lapels added.
- Make sure the waistcoat is long enough to cover the top of the trousers – it looks dreadful if an expanse of shirt or stomach appears between trouser and waistcoat by mistake.

SUITS AND JACKETS

It is not easy to find suits and jackets that can adapt convincingly. Try to build a collection of

useful or unusual suits and jackets as they tend to be difficult to find when you need them.

- Tailcoats and morning coats. You can add higher collars and alter the shape of the tails.
- Lightweight overcoats. At least the collar, shoulders and buttons are there and you can re-cut the rest.
- Uniforms often have an interesting cut, buttons and braid can be altered.
- It is possible to make a representative version of a Victorian tailcoat by chopping up a suit. Cut the jacket off at waist level and

take it in so that in fits neatly round the waist when buttoned. Use the trouser cloth to make tails, line with a suitable fabric and cut cuffs and pocket details from the scraps. It will be at its best when worn open over a waistcoat and appropriate neckwear.

DYEING AND PAINTING

A dip in the dye pot can produce dramatic alterations. Easy-to-use dyes are available in hardware and haberdashery shops. Instructions on these dyes are clear and precise, and there is usually a telephone

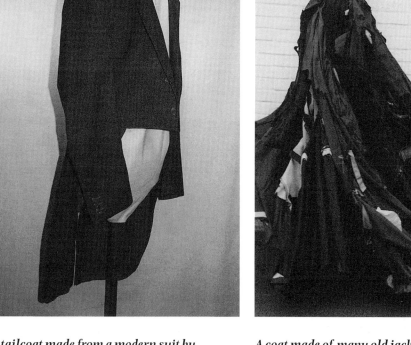

A tailcoat made from a modern suit by re-modelling the jacket and cutting coat tails from the trousers.

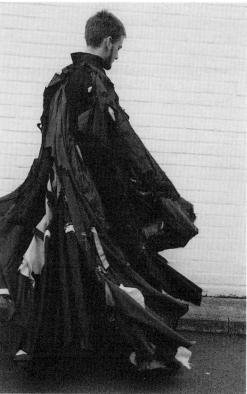

A coat made of many old jackets stripped of their linings, turned inside out to look ragged and sewn into a full-skirted greatcoat.

127

number on the leaflet that you can ring for advice. Read the instructions on the dye pack and buy one suitable for the fabric. Follow the instructions exactly at first to get the idea, then branch out and experiment.

Fabric can be dipped, painted, crumpled, plunged, and splashed – a messy but exciting business. Try taking a paintbrush of bleach to a non-fast dye and see what happens (wash it off quickly or it will rot the fabric). Try dying the cloth, crumpling it and rubbing it round the dye pot in an inch of a stronger version of the same colour to grub it up.

- You will need a huge saucepan – one big enough to hold several buckets of water, as some dyes on certain materials will need to be boiled.
- Some instructions tell you the dyes can be used only on natural fabrics. Viscose is made of wood and is consequently a 'natural' fabric as are cotton, linen, silk and wool. Feathers, wood shavings, some buttons, braid, canvas shoes, string and

Bunches of shoelaces hanging up to dry after a dip in the dye pot before being used to make a hairy monster.

tape can all be bubbled or dipped in the dye pot. Articles are often made of a mixture of components, only some of which take dye. Cotton/polyester is an example. You will find when you try to dye it that the colour lacks intensity because only the cotton in the weave picks up the dye. When you make clothes to be dyed, use cotton thread – white polyester stitching will shine out as it will not absorb dye.

- Line a sieve with muslin and lower it into the dye pot when you are dying small things like buttons, or fringes which tangle easily.
- You can never be sure what is going to happen in the dye pot until you try!
- Machine dye is excellent for dying sets of clothes and larger items. Imagine putting a pair of white gym shoes, cream cotton socks, some white laces, a pale grey skirt with red stripes, and a yellow blouse in the washing machine with a bright blue dye. The result would be basically blue but the red stripes would be have a purple tinge and the yellow blouse a greenish-blue hue. The colours would all look as if they were related. For this reason, it is a very good way to make a jumble sale bag of cotton clothes look as if they are meant to be together.
- Remember to look for a label on the inside seam of clothes as well as at the back for fabric information. With experience, you will get better at identifying fabric. You will notice that the fabrics feel different in your fingers and smell different when heated by the iron. They will behave and smell differently when some shreds are burnt with a match – try this with some tiny samples of polyester, cotton and wool. As a general rule, fabric that shrivels up and dies when you put a match to it will be more difficult to dye. You can also get a good idea of how well a fabric will take dye by mixing a pinch of dye in a cupful of boiling water and dipping a sample.

Painting spotted detail on a costume with emulsion paint.

- Lycra cannot be dyed in an automatic washing machine, as the water has to boil.
- Shoes can be dyed with leather dye, shoe dye, or they may be simply painted. It works well to use several thin layers of car spray paint, which is available in a huge range of colours.
- Many different paints may be used on fabric. Some of them will stiffen the cloth, which may be all right for shoes and hats, but not so good for clothes. However, it is worth trying anything you have to hand in the workshop on a spare bit of cloth. Ordinary household emulsion can be brushed on sparingly with a near-dry brush to create grubby patches and bloodstained bandages. A thin coating of PVA adhesive, left to dry on the fabric, will stiffen the fabric and make it slightly shiny. A dip in cold tea will age bright white fabric. Coloured inks are useful, though they may wash out, as they do not alter the texture of the cloth. The same is true of the sort of leather dye that smells like surgical spirit.
- Use a paintbrush dipped in dye to highlight or alter a patterned cloth.

In addition to all these hit-and-miss methods there are proper fabric paints with all sorts of finishes if you can afford them.

10 LARGE CASTS AND SMALL BUDGETS

There will be times when you will have to clothe a large cast. This requires an unusual blend of fanatical organization and brave imagination. A large professional cast is expensive, and if the company can afford to pay fifty or more actors, they can probably afford a budget to clothe them. A more likely situation for this sort of work is a

Actors in costumes collected from a jumble of clothes. Photo: Robin Cottrell

play performed by a school, college or youth theatre, or perhaps a community play. In these cases the budget may be minute.

ORGANIZING THE ACTORS

The actors may be unused to the discipline required to keep fifty pairs of shoes in order, let alone tights, socks, bags, and the actual costumes. Imagine the chaos that can occur in the rush of a dress rehearsal when all these people have to put down their bags, coats and sandwiches, change out of their day clothes and into their stage clothes and make-up. And then reverse the whole palaver without losing their front-door keys, purses and watches, leaving everything ready for the next performance.

Dressing room space may be in a tent or hall and it becomes vital that each member of the cast has her own named or numbered space. In an ideal situation this will be a clothes hook, a

Children who help make the costumes look after them more carefully.

hanger and a seat. It may have to be just a chair, but at least each person will know where her possessions and costumes should be, even if the odd shoe has wandered. Ask actors to bring a carrier bag so that they can hang up their small accessories, and try to impress on everyone the importance of keeping everything off the floor. Ask the stage or production manager to arrange a box for valuables that can be locked away during the working period. This may not theoretically be your responsibility but it will certainly involve your time and concentration if things get lost or stolen. When clothes rails are available, each person should have their own named or numbered hangers and a carrier bag for bits and bobs. Clothes that are hired or borrowed should be checked in and out by a member of the wardrobe staff every day unless you are absolutely certain of the honesty of your cast and the security of the changing room.

Children in the theatre

In a professional company, care of the children will not be your responsibility. In youth theatre or community work, it is often assumed that the wardrobe department will look after children who are not onstage under the eye of the stage manager. Enquiring parents, thirsty children and bleeding noses usually come to the wardrobe for help and succour. This is not a practical proposition. Ask the production manager to enlist the support of responsible adults to look after the children. Provide them with lists of where each child has to be for their entrances and exactly what they should be wearing. Make sure there are enough adults to ensure that children are looked after at all times. The combination of dressing up and having to hang around keeping quiet, punctuated by bursts of exciting activity, make theatres and children a volatile, if exciting and fruitful, combination. There is a lot of dangerous equipment around theatres and

131

Children Backstage

If there are children in the cast, great care must be taken in the organization of changing space and chaperones to give children privacy and safety.

children really do need to be watched. The production manager will most probably have made all these arrangements, but check to make sure.

COSTUMING THE PLAY

You have to drum up the enthusiasm and support of the company and make sure they understand what you are trying to do. As with all basic costume it is best to create a structure of footwear, trousers or skirt, and top without recourse to the budget, and the more of their own clothes that the actors can provide, the better. The suggestions already discussed in the basic costume section may also help.

Arrange a meeting at the start of the project and explain the effect you are hoping to create. Be very clear and provide drawings, samples and photocopies to take away if you think it will help people to visualize your ideas. Encourage discussion and questions. Arrange for everyone to come to the next session with any items they think might be useful. Make it obvious that you do not expect everybody to rush out and shop – students are usually broke and children may get the impression that they are not allowed to be in the play unless they have the right clothes. You may also have to cope with the disappointment of a misguided enthusiast who has laboured day and night to produce a creation that will look utterly out of place in the total scheme of things.

At this second meeting see everyone in the clothes they have found. Write a list of anything that is missing from each person's basic costume. It is a good plan to do this in a group, as many people will offer to lend items to those without. It will also give a better understanding to anyone who has not quite grasped what it is you are looking for. Now is the time to produce samples of the additions you will make to the basic costume to turn its wearer into a Dickensian child, a troll, or a sylvan peasant. Dress one person from each group of characters in the sample over their basic costume and explain or demonstrate the variations you envisage.

It is possible to create a few very simple patterns for accessories, such as turbans or aprons, that can easily be made by the actors themselves. Use your own experience of bargain shopping to buy cloth, or ask people to bring in their own remnants of cloth so that you can judge the colour groupings.

You may find it works to dress the various groups of characters in different basic costume. In most plays, there will be one or two main characters that will require special costume and you will have to arrange separate fittings with them.

PRACTICAL EXAMPLES

Here are two examples of large-scale work, which might serve to demonstrate how to put these ideas into practice.

Whale by David Holman

Directed by Chris Baldwin for the Youth Theatre Group at Harrogate Theatre, the production team was professional. The company of actors comprised seventy young amateurs aged from 5 to 19 years, playing 110 roles. In addition, there was an ultraviolet lit

underwater scene, which transformed each actor into a sea creature. The costume budget had to be stretched to include the construction of three giant whale puppets.

The amount of money available would have bought a T-shirt and pair of shoes for each performer, which would have been pretty dismal for both actors and audience. Much imagination was required from the costume department, and a great deal of goodwill from the actors and their families, to create costumes for so many characters.

The most expensive purchase in the production was a pair of soft-soled dancing boots for the raven, a central character who needed the confidence given by the supple grip of the perfect footwear to cope with some quite athletic movement. Other actors were asked to provide their own shoes.

A goodly proportion of the budget was spent on dye. Children were asked to bring in any outgrown or unloved cotton clothes. These were dyed by the wardrobe department in batches to create the following groups:

- Ten American golfers – a different colour for each of the four families. Clothes with patterns on a white background were chosen, so that the final effect was brash, vivid and complicated as the white background took the dye and the patterns did not.
- Tour guide and fifteen younger children as tourists – all plain white clothes dyed bright yellow and worn with pink plastic sunglasses and pink socks. The wardrobe bought the socks and sunglasses.
- The sea goddess's eighteen watery companions – very young children all in black and wearing gloves with fabric streamers sewn on to the fingers. The wardrobe bought the gloves.
- Inuit girls of today – the children were asked to search their family wardrobes for warm

This basic shape of this costume was made in the wardrobe and the children shredded cloth to make the fringes, knotting the tips for extra weight.

133

winter clothes so that each character could be dressed in her own particular colour. Thus, one child was all in pink and another all in green – gloves, shoes, scarves and all. Some of the footwear had to be painted by the wardrobe. This was the hardest group to organize but created the most stunning effect against the icy set and used none of the budget.

- Inuit families from the past – they wore their own unremarkably coloured clothes with the addition of simple, hooded coats stencilled with Inuit patterns and edged with fake fur.
- Three polar bears – they wore white suits (actually adapted chef's uniforms) and white Al Capone-type hats (the second most expensive wardrobe purchase).
- Three small whales – represented as waterspouts in shredded, white cotton-jersey which sparkled like water in the ultraviolet light as they whirled. The wardrobe, with the help of the children, sliced and fringed old white T-shirts to make these costumes.
- Russian sailors in white suits made of thick, cheap curtain interlining and 'fur' hats.
- Fifteen very young children as seabirds in their own or borrowed black tights, leggings and jerseys. They wore wings with hoods made of grey nylon jersey and stencilled with eyes and feathers.
- A Minneapolis family – all in assorted denim outfits from dungaree shorts for the youngest to jacket and jeans for the oldest.

The wardrobe made costumes for the more central roles, mostly adapting them from charity shop finds. The underwater scene was made largely from bric-à-brac that reacted to ultraviolet light, glued or stitched on to non-reactive clothes and hats. Some clothes and hats were painted with ultraviolet-reactive paint.

When time is short in circumstances like these, it can be good to harness enthusiasm and create a workshop situation where the cast themselves do work on the costumes under the tuition of a wardrobe worker. Patterns, supplies and space have to be well organized and instructions clear and precise. In this way, thirty masks which might take the wardrobe four days of repetitive work could be made in a morning. Children who make their own costumes will take more care of them in the dressing room and onstage.

Vanity Fair

This version of Thackeray's novel, set against the background of the Napoleonic Wars was adapted and directed by Francesca Byrne for St Mary's University College at Strawberry Hill.

The cast comprised thirty young women who played all the parts, including becoming streets, furniture, ships and carriages. The problem was how to create the rather formal silhouette of the costume of both men and women of the era in an adaptable and non-naturalistic way.

All the women were asked to bring black trousers, leggings, opaque tights, long-sleeved tops, bodies, leotards and shoes to a meeting after the first read through. Out of these garments a selection was made of the most cleanly silhouetted and flattering shapes and the lightest shoes. Anyone who was playing a man was asked to use a heavier pair of shoes or boots when they adopted that role.

The cast was shown examples of the hairstyles of the time and asked to practise re-creating them at home. No attempt was made to pretend the women were men other than the way they acted and the coats and hats they wore.

When playing men, the women added a modern tailcoat (such as conductors wear) or morning coat (as is sometimes worn at weddings) and a representation of a shako (a nineteenth-century army hat). They put these on in full view of the audience. The simplified

Soldier's shako and a bonnet made as simply as possible to clarify the roles taken by the company as soldiers or young ladies. Photos: Robin Cottrell

shape of the shako was made from heavy felting and a few men's evening tailcoats and morning coats had been borrowed or bought second-hand.

When the actors played women, they wore a full-length tabard of lightweight, pastel-coloured fabric which was held in by an elastic belt under the bust to create an Empire line. They also wore simple, identical white bonnets. Very few accessories were used, apart from a few walking sticks or posies. The idea was to inform the audience of the period and let the script and imagination supply the deficit.

135

11 CHANGING THE BODY SHAPE

Suggestions in this chapter make use of equipment that can be obtained easily and is relatively cheap. There are countless other methods but many of them demand expensive materials and more complicated skills.

There are occasions when costume has to become less like clothes and more like sculpture. The shape of the body may need to be changed and perhaps its human shape disguised. The faces of a group of actors may need to be altered or stylized with masks.

The outside and inside of the head of a Chinese dragon puppet. Photos: Hannah Bicât

Padding may be needed for a character who must become fatter or thinner during the course of the action, or to reflect the gradual changes of pregnancy. An actor may have to become a cat or a mountain, cholera, or a dung beetle. Some of these changes need leaps of imagination and some careful anatomical observation. Nearly all require the help of the costume maker.

PADDING

Padding should appear to be part of the body. It should be constructed so that it will move with the body, and cannot shift around of its own accord. The most reliable way to ensure a successful result with body padding is to build it up on a leotard-shaped garment which the actor puts on underneath the costume. This will ensure that when an actress sits down onstage, her eight-months pregnant belly stays snugly in the right place and does not shoot up to her neck. The same applies to beer-guts, bottoms, hips, and on some thin male bodies – breasts. Base leg padding on tights or lycra shorts.

Deformities must be carefully re-created or they may appear comic when they are not supposed to. The audience finds it easy to spot a lack of symmetry in a body and because of this, very little padding can be used to great effect. The combination, for instance, of one built-up shoe heel, one slightly too-long cuff and a small shoulder pad may give a better effect than a large hunchback padding.

Look at people to understand:

- How you can tell someone's age from their back view.
- The difference between the neck of a 20-year old and a 50-year old.
- What happens across the back of the shoulders as people get older.
- The shape of a pregnant woman.

Padding for the shoulders and the small of the back sewn into a coat for a quick change.

- Where on the body extra padding is needed to make someone look fatter convincingly.
- The differences in the ways body weight is distributed in men and women as they get older or fatter.
- What, apart from size, makes bodies at various stages of childhood so different.

Most of these changes can be suggested by padding. The difficulty is usually the neck. It is no use making a convincingly fat, elderly body shape when a smooth young neck swans out at the top. A neck can be made to appear shorter by building up the shoulders of the actor, and make-up can help if skilfully applied. It is easier for a slim young actor to look older by making him appear gaunt rather than plump.

Using Padding

Always make and fit the padding before you make and fit the costume that will be worn on top of it. Paddings are hot and get sweaty to wear and need to be washable. If it is not possible to get the padding dry between shows, a second one should be made. Wearing the padding over a T-shirt or vest will cut down the washing.

- Before you make a padding have a thorough but subtle look at someone whose build matches the one you are trying to re-create. Use washable wadding to build up the shape and thickness you need.
- Cut circles and ovals rather than squares or rectangles.
- Build up the layers in ever decreasing shapes and sandwich the hillock together with a piece of wadding smoothed over the whole edifice.

- Make sure the shapes you create have no sharp edges.
- Put dabs of glue between the layers to hold everything in place as you build.
- Even a small amount of padding can greatly alter a shape, so keep checking the outline against a body as you go along, even if it is only against yourself in the mirror.
- Padding always looks bigger on the body than on the worktable.

When you have achieved the right shape, cover it smoothly with a light, stretchy cloth such as dishcloth cotton, an old T-shirt or thin lycra. Stitch through all the layers on to the foundation garment using a big needle and strong thread. These stitches should be big, strong and loose or you will end up with the effect of a button-back sofa.

Stitching a backing on to a bra of the right size and stuffing the resulting cavity can make realistic breasts. Lentils make particularly good breast stuffing, as they are the right sort of weight and move in a convincing way. But don't wash them or they will sprout! Breasts tend to slip up on thin male bodies and need to be anchored firmly in the right place to look convincing. Some actors may find it more reassuring if realistic false breasts are built into a waistcoat, rather than a bra-shaped foundation. Comedy breasts are a different matter and easier to cope with for both actor and maker.

Breasts may need to be disguised by various means if an adult actress is playing a child. They can be bandaged with crêpe bandage or similarly stretchy strips of cloth. They can be flattened by a wide band that hooks at the back like a deep bra. On a small-breasted woman, a tight vest or sports top will do the trick. Whichever method you use, it should be adjustable and not tight enough to hurt. The cut of the clothes worn on top should help to disguise any inappropriate bumps.

Creating the bulk of padding with layers of wadding.

CHANGING THE BODY SHAPE WITHOUT PADDING

Many apparent changes in the body can be achieved with just the cut and colour of the costume.

- Trousers can be cut high above the natural waist or suspended below the waist on braces to make the legs look longer or shorter.
- Trouser hems and cuffs can be shortened or lengthened to similar effect.
- The sleeve seam on the shoulder can be set slightly too near the neck to make the shoulders appear narrow and the arms longer.
- Shoulder pads can be used to create a stockier or more powerful build, or to raise the entire shoulder line and make the neck look shorter.
- The position of a waist seam above or below the natural waist can make a great difference to the look of a body.
- The position of braid and decoration and the use of stripes, plain colours or contrasts can all alter the way the actor's figure looks to the audience.

It is impossible to predict how well these alterations will work. On some bodies a slightly overlong, slim-cut sleeve will add length and elegance, but on others it will look like a child's school blazer – bought to grow into. It depends on how the actor's real body shape and natural style of movement relates to the body shape and movement you both hope to create for the character. The best way to get the right

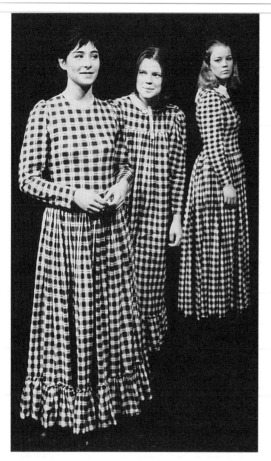

A costume cut in different ways to emphasize the different ages of the same character. Photo: Robin Cottrell

effect is to experiment with an assortment of clothes and some wadding in front of the mirror.

ANIMALS

Always begin by studying the actual animal if you possibly can. If this is impracticable, look at as many photographs as you need to build a picture in your mind of how the animal moves, as well as its appearance. The best reference for animals can be found in the children's section of the library. There, the direct and simple information will give you a clearer picture of the way in which an audience will recognize an animal than the most specialized and learned descriptions. You will already know the character of the animal, and the way the audience should relate to it. Some stage animals need to be accepted as real whilst others may have human understanding and speech. When making animals for children's plays, remember that most children love to stroke and touch animals. The texture of the costume should appeal to the child's sense of touch even if the actor is out of reach onstage.

If you are making for a designer, you will have their drawing. Make sure that the way the animal has been designed can be re-created on a human body, and that the actor will be able to move, speak and hear when wearing the costume. It can be easy to draw a realistic design, but not so easy to make or wear it. Discuss with the designer all the points that might cause difficulty before you start cutting.

Pay particular attention to the following points:

- As well as looking right, footwear must be practical. It is easiest to build the animal foot on a strong, comfortable shoe or boot.
- Headwear should not inhibit sight or hearing (or speaking and singing if the animal talks).
- It is particularly important to make sure that the girth measurement (the measurement from the back of the neck to the front of the neck taken between the legs) is sufficiently long for the actor to crouch. The distance from the nape of the neck down the spine to the crutch increases dramatically when the back is arched – try it and see. An actor's movement will be

An ass's head made of scrap copper tubing.

severely hampered unless allowance is made for this increase.
- Fur fabric is hot to wear, slow to dry and should be worn over sweat-absorbing underwear.
- It is often very uncomfortable to wear an animal costume. Try to make it so that the actors can free their hands, remove the head and undo the front of the costume easily when they are offstage.

There is always a decision to be made about the visual reality of an animal costume. A cat could have a complete furry costume with a full head-mask and paws; a bodysuit, tail and cat-like movement; a furry body, top hat, tail

A magic fish made from bubble wrap and corset bones.

141

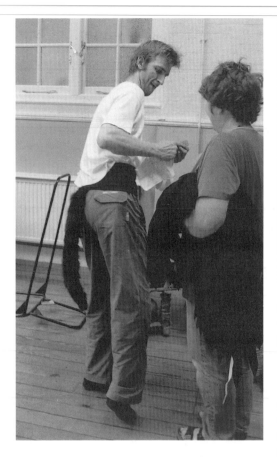

Stiffening antlers made of fabric and wadding-covered corset bones by smearing them with PVA adhesive. Photo: Hannah Bicât

Checking the swing of a cat's tail made of a fur-covered rubber toy snake. Photo: Hannah Bicât

and whiskers; or just a cat-like attitude. The audience will accept all four as cats as long as the style is in keeping with the spirit of the production.

There are also all sorts of odd problems to be resolved. Should the tail be attached to the costume or the actor's body? Can actors manage their props, open door handles, and climb safely with paws instead of feet and hands? And, if a cat wears a hat, what on earth do you do about the ears?

Be aware that you are not creating an accurate copy of the animal. There is often a difference in scale between the animal and the costumed actor. This would only worry the audience if the costume were utterly realistic. Audiences are quite able to believe a tall adult is a rat but most would run screaming from the theatre if a real six-foot rat scuttled across the stage. To make animal costumes you must identify the shape and features that make the animal recognizable as a particular species and trust the audience to translate it.

ABSTRACTIONS AND MONSTERS

An actor, or group of actors, will sometimes need to appear as an inhuman or abstract concept. You might have to create a costume for wind, a ghost, the moon, a teabag, the Minator, hatred, or a dinosaur. This sounds as if it would be a matter purely for the

imagination, but it is not. It takes careful study of the script, a complete understanding of the play and an absolute certainty of the way the production will be directed, to make the abstractions come to life

Books and museums can provide pictures of a Tudor shoe or a Tudor ruff – but what about Tudor hatred? You have to understand what that hatred feels like in the director's concept of the play and the period, and translate that feeling into a costume. You must know how the character will move, and the sort of lighting or sound effects that will accompany its appearance onstage. You must be sure of the way the director wants the audience to react. When making this type of costume for a designer, you must be absolutely sure that you understand his requirements or you will never be able to make the costume match his idea.

Imagine you are making a costume for wind. Ask yourself what sort of wind. Is it a gentle wind ruffling the hair of lovers, a killer tornado battering everything in its path, a lewd and smelly fart, or a playful breeze stealing hats and muddling letters? Will it be accompanied by a sound effect or make it own noise? Will it whirl about the stage dressed in ultraviolet shreds of rustling polythene or puff from the corner in a doublet like the blowing cherub on a sixteenth-century map? Whether it behaves more like an elemental force or a person with a brain determines the degree of abstraction or reality in the costume. Good communication between director, actor, designer and maker is vital for this type of costume. The best way to understand how the role is developing is to look in at an appropriate rehearsal before you cut the cloth. And of course, as always, to watch, listen and talk.

12 TECHNICAL AND DRESS REHEARSALS

With luck and good organization, the costumes should be complete and waiting in the dressing rooms. The stage manager will have a dressing room list so that you can put things in the right place. When you set out the costumes it will help if each actor's accessories are grouped together and labelled, particularly if people are dressed alike. Where there are no proper dressing rooms make sure in advance that there are chairs, mirrors and lights, and somewhere to hang costumes and put accessories.

THE DRESS PARADE OR DRESS CALL

This is an occasion when the director, designers and maker can see the actor onstage in the complete costume with all its attendant accessories. It will be the first time that the whole cast is in costume and can be of great value to the entire company. You will be able to make a list of any points that need alteration, and any likely complications that should be discussed in advance of the dress rehearsal. You have to balance the workload resulting from any changes with the amount of time and money available. There is no need for a separate dress call when you are working with a small company and have a straightforward costume plot. The fittings and the technical rehearsals will give you enough information

and time to do alterations. Quick changes, special effects, a complicated costume plot or a large cast, make a dress call essential if everything is to be ready in time.

As the first night approaches, time seems so short and so valuable that it becomes hard for the director to spare actors' rehearsal time. Only insist on a dress call if you are certain it is absolutely necessary for the wardrobe to have advanced warning of complications that you would be unable to resolve in the time between the technical and dress rehearsal. Give the stage manager as much time as possible to arrange its inclusion in the schedule.

TECHNICAL REHEARSALS

These can, and frequently do, go on for days and nights. They are the rehearsals for any technical aspects of the show. Every lighting and sound cue, scene and costume change, entrance and exit is rehearsed, often over and over again, to make sure it will work smoothly in performance.

Technical rehearsals can be the most surreal experiences. Imagine – the auditorium is dark and empty except for somebody's mother reading the paper in the upper circle and a shadowy, blue-lit group round the director at a temporary table in the stalls. Absolutely nothing appears to be happening except the sound of the director sighing in the

144

blue light. An actor wanders onstage dressed as Charles I but wearing a baseball cap because as his wig hasn't arrived. He holds a chipped teapot out towards the darkness and asks 'Is this it?' Nobody answers. The lights onstage go off and come on again. Nothing continues to happen and he wanders off. Meanwhile, backstage there is frenzied activity as someone rushes round trying to locate the decanter for which the teapot is a stand in. Everybody is desperately trying to get his or her job done in time for the next cue and the stage manager is outwardly calm but inwardly demented.

The wardrobe is in ferment over the missing wig and the huge list of alterations that gets longer every minute. Keep a notebook and pencil at hand every moment to record the succession of small points to be dealt with later. If there has been no dress parade, the actors will be in their costumes for the first time and may have forgotten which shoes go with Act III's dress or how to wear their cravat. Because technical rehearsals involve endless delays, corsets and boots which in performance are worn for a couple of hours become tight and uncomfortable. Everyone finds small problems, but there is always the worry that someone will find a big problem that will involve a major re-make of costume.

Keep calm and pretend to be unflurried. The endless pauses will mean you can work through your list during this protracted rehearsal, and it is usually the one time when the actors are available when you need them. Try to have a supply of hair grips, hat pins and safety pins; innersoles and a hole punch (for belts and shoes); ready cash for last-minute errands and any other items you can

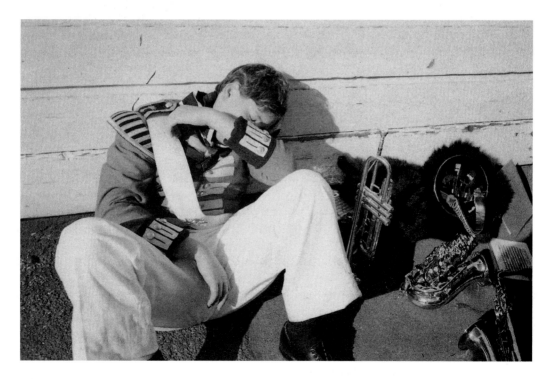

A young actor resting during a lengthy technical rehearsal.

think of that will save a journey to the shops or an addition to your list. It will be a huge help if you have someone working with you, even if they can't sew. They can run to the shops, field questions, and carry costumes and messages about while you are watching and taking notes.

When the rehearsal finishes it is time to sit down and sort out the work schedule to make sure everything is ready for the dress rehearsal.

DRESS REHEARSAL

If everything goes smoothly this will be exactly like the performance without the audience. With luck and good management, the finished costumes will be waiting in the dressing rooms before the actors arrive. The dress rehearsal is the first time you see how the actor wearing your costume, on the set and in the light, becomes the character you envisaged when you first read the script. You should watch the whole performance with a critical eye on the costumes and note anything you feel you should change. Move around every so often so that you look from all angles and distances. This is your last chance to get things right before the first night. It is a tense time and very exciting.

It is also the time when, exhausted and grubby, you can have the marvellous experience of seeing your dreams come to life, and you will understand why such a daft, demanding and difficult job is also so fascinating, rewarding and delightful.

FIRST NIGHT

A first night company is tense – most people are sick with fear and thudding with adrenaline. The whole atmosphere backstage tightens and is strangely quiet after the last-minute hammering on the set and the weird

The author, notebook at the ready, cuts a bodice on the pavement after a last-minute change during open-air dress rehearsal.
Photo: Hannah Bicât

vocal exercises of the actors. It is comforting for the company if someone from the wardrobe does a round of the dressing rooms about half an hour before the show starts to check that all is well with the costumes. Someone will be having last-minute fears about their tie knot or their hair bun, and a reassuring tweak will settle things. Then hang about near the greenroom (the actors' sitting room) or the wings. Try to be calm, quiet and as near invisible as you can manage. Have a small emergency kit with you of needles, thread, scissors, sticking plaster, safety pins and the

odd button so that if there is a last-minute emergency you can cope without rush and drama – there will be quite enough of that in the actors' hearts.

Five minutes before the show starts, the atmosphere changes into one of serious and silent concentration. All the ideas and work, the dreams and aspirations wind together – the play begins, and that unrehearsed member of the company, the audience, joins the actors.

BIBLIOGRAPHY

Arnold, J., *Patterns of Fashion 1560–1620*,
ISBN 0333382846

Arnold, J., *Patterns of Fashion 1860–1920*,
ISBN 0333136017

Bray, N., *Dress Pattern Designing – The Basic Principles of Cut and Fit*, ISBN 063201881X

Buck, A., *Clothes and the Child – A Handbook of Children's Dress in England 1500–1900*,
ISBN 0903585294

Bull, W. M., *Basic Needlework*,
ISBN 058233067X

Cumming, V., *The Visual History of Costume Accessories*, ISBN 0713473754

Doyle, R., *Waisted Efforts – An Illustrated Guide to Corset Making*, ISBN 0968303900

Dryden, D. M., *Fabric Painting and Dyeing for the Theatre*, ISBN 0435086243

Hastings, P.J., *Sewing Shortcuts*,
ISBN 0806906553

Holkeboer, K.S., *Patterns for Theatrical Costumes – Garments, Trims and Accessories from Ancient Egypt to 1915*, ISBN 0896761258

James, T., *The Prop Builder's Machining Handbook*, ISBN 1558701664

Motley, *Designing and Making Stage Costumes*,
ISBN 1871569443

Peacock, J., *Costume 1066–1990s*,
ISBN 0500277915

Pepin Press, *Hats*, ISBN 905496054X

Pratt, L. & Woolley, L., *Shoes*,
ISBN 1851772855

Swin, C., *Maskmaking*, ISBN 0871921782

Swinfield, R., *Stage Makeup Step-by-Step*,
ISBN 155870390X

Threads Magazine, *Beyond the Pattern – Great Sewing Techniques for Clothing*,
ISBN 1561580945

— *Fit and Fabric*, ISBN 0942391810

Waring, L., *Hats Made Easy*,
ISBN 1863511504

Waugh, N., *The Cut of Men's Clothes 1600–1900*, ISBN 0571057144

— *The Cut of Women's Clothes 1600–1930*,
ISBN 0571085946

Wills, L., *The Complete Idiot's Guide to Sewing*,
ISBN 0028638913

Willets C. & Cunningham, P., *The History of Underclothes*, ISBN 0486271242

Winslow, C., *The Oberon Glossary of Theatrical Terms*, ISBN 1870259262

Wolff, C., *The Art of Manipulating Fabric*,
ISBN 0801984963

— *Fit and Fabric*, ISBN 0942391810

USEFUL AIDS TO SPEED AND INVENTION

The facts and suggestions which follow might save you time when you start working with costumes. Some are obvious and some less so, but all are useful and may help you not to have to learn by your mistakes. They will at least give you confidence in your own judgement and ideas.

GENERAL

1. Be careful not to make armpits too tight. Acting is a sweaty business.
2. If a zip is hard to work, 'oil' it by rubbing with lead pencil or candle wax.
3. Ask actors not to fill tight costume pockets with too many non-prop items – the light catching the outline of a square-edged cigarette packet is unmistakable.
4. Few people are allergic to silk and smooth cotton but many are to wool and rough textures.
5. A very short-sighted actor may like a pocket in his costumes so that he can put on spectacles in the wings to check props, etc.
6. It is easy for actors to forget they are wearing a watch or ring which may be inappropriate onstage.
7. It is much easier to cut and make pockets with the garment than to add them in a hurry at the dress rehearsal.
8. Mark the centre back of trousers or skirts clearly if the shape of front and back look similar or the change is quick.

9. Keep all fabric scraps until after the first night and reserve a selection for mending and patching to be kept by the wardrobe for maintenance.

ACCESSORIES

10. Cuff links can be made by linking two suitable buttons with strong thread.
11. Don't forget wedding rings where appropriate – someone's bound to notice.
12. Stuff handbags and baskets so that they don't look oddly empty onstage.
13. Cut off the fingers of gloves to make mittens.
14. To remove lenses from spectacles without the right size screwdriver, wrap in old cloth to stop the glass spreading and whack with a hammer. Check the frames carefully afterwards to make sure they are safe.

BODICES AND TOPS

15. Sharp corset bones can be covered with sticking plaster or masking tape until you have time to cover them properly
16. Fasten tight bodices from waist to neck rather than neck to waist. Then you can adjust the position of the bosom as you proceed.
17. When taking in T-shirts or jerseys, stitch first and trim and finish afterwards – the fabric is less likely to stretch.

18. Small brass safety pins can be zigzagged into costumes to control bra-straps, ribbon bows, ties, etc.

DECORATION

19. Stick a pattern of upside-down sequins on masking tape. Put glue on the sequins and press onto the cloth. When dry peel off the masking tape.

20. Any pattern on a cloth can be enhanced or altered with paint or sequins.

21. You can make fairly convincing ostriches with fringed paper or cloth supported by wire as long as they are not seen alongside real ostrich feathers.

22. Paper doilies make good stencils for lace patterns.

23. Use your toe to keep a regular or variable tension when plaiting a braid.

24. Thin wire can be zigzagged over by machine.

HAT, HAIR AND HEAD

25. Check that an actor's fringe doesn't create a shadow over the eyes under stage light.

26. Hair in a ponytail can be brought forward under a hat to make a fringe.

27. Fine hairnets don't show onstage and will tame recalcitrant locks and hold back stubborn fringes. You can buy small ones for buns.

28. Glue hair decorations onto small combs and they will stay anchored in the head more firmly.

29. Keep an elastic hairband on your wrist at fittings to keep long hair away from the scissors.

30. Use double-sided toupee tape (obtainable from wig suppliers), to attach beards and moustaches in quick changes.

31. A 2in (5cm) strip of thin foam rubber sheet round the inside of a hat is a good way to make it smaller or make it cling to the head of a jumping actor without elastic.

32. Ask inexperienced actors and children whether they can work without spectacles and whether they have contact lenses – they may not have considered the matter.

33. It is difficult for the audience to gauge an actor's expression if they can't see the eyebrows clearly.

34. Hat elastic can be made up with face make-up if you do not want it to show.

35. Its sometimes more successful to sew false hair onto a hat than to wear a hat over a full wig.

36. Beg actors not to cut their hair between first fitting and first night without talking to you first.

37. Mascara has a great effect on men eyes as well as on women's.

38. Nose studs can be disguised with a tiny circle of sticking plaster or masking tape. The most important thing is to stop them catching the light.

39. Small circular sections of tights, stockings or socks make good stretchy hairbands and won't damage the hair.

40. The leg of an old pair of tights or stockings will keep the hair out of the way under a wig or when applying makeup.

41. A chiffon scarf over the head when dressing will keep make-up off the costume without mucking up the hair-style.

MACHINE

42. Costumes make dust and fluff so remember to clean the bobbin compartment of your machine regularly.

43. Stick strips of masking tape on your machine bed as an extra guide when stitching wide hems or braiding.

44. Machines are more efficient if you change the size of their needles for different jobs.

45. Have as many bobbins full of as many colours as you can.
46. It will save your fingers if you learn to sew on fastenings by machine particularly on heavy cloth. The machine instruction book will tell you if you machine can cope.

MASKS

47. Make the eyeholes in masks by stabbing through from inside to outside to leave a smooth interior surface that won't tangle with eyelashes.
48. Enlarge the eyeholes in masks with a tapered paintbrush handle. Mark the place on the handle to end up with equal eyeholes.
49. Using P.V.A.glue on papier-maché makes it strong and supple – good for masks.
50. Adjust the way a mask sits by gluing strips of foam inside.

ORGANIZATION

51. Clothes pegs strung on a line are useful to keep different pieces of work-in-progress safely together and out of the way between fittings.
52. Make sure the coat hanger is strong enough for the job.
53. Sew loops in everything, hats, socks and all when space is tight – people are more likely to hang things up if it is easy.
54. Baskets of costumes are easier to carry than cardboard boxes.
55. Never move about the theatre without a notebook, pencil and a pocket of safety pins.
56. Don't underestimate the importance of making a list or the satisfaction of crossing things off it.

QUICK CHANGES

57. The easiest way to put on a tight jacket or bodice is for one person to hold it open behind and the wearer to hold their arms back downwards.
58. The quickest way to take off a tight top is for the wearer to bend forward with outstretched arms and the dresser to strip the garment off inside out.
59. When an actor has to wear one pair of trousers on top of another for a very quick change, it is sometimes possible to make the top ones too big and without fastenings so that they are suspended by braces alone and drop off easily.
60. Round hat elastic instead of shoelaces can speed a quick change.

SOCKS, STOCKINGS AND SHOES

61. Socks show when an actor sits down onstage.
62. A pair of thin seamed tights can be worn under another pair if you can't find or afford any seamed ones of the right dernier.
63. Two pairs of thin tights make one pair of thick ones.
64. Its not as difficult as you might think to make thick tights and stockings in stretch fabric – iron the leg of an old pair flat and use it as a pattern.
65. Check the soles of shoes for price labels which might show when an actor kneels onstage.
66. Make sure actor's shoes are clean or dirty according to character.
67. Make sure actors have dance supports or jock straps to wear under tights.
68. Innersoles which can be changed prevent smelly shoes.

Sewing

69. It is often easier to make the fastenings before you make up the garment.

70. It is quicker to use button thread or other strong thread for fastenings.

71. It is sometimes easier to make neat buttonholes in flimsy material if you starch the cloth first.

72. Notch a piece of card to use as a guide when measuring hems of positioning braid. It is quicker than using a tape measure.

73. However roughly or quickly you are sewing, take time to fasten the thread on and off securely.

74. Check the right shoes are being worn before you mark a hem.

75. Remind actors to look straight ahead when you mark a hem. If they look down the skirt will be too short in front.

76. Pin bodices with the pins pointing down at the armpit and up at the waist to avoid stabbing actors at fittings.

77. Many children and a few actors are frightened of pins at fittings.

78. Masking or gaffer tape will secure hems in an emergency.

79. Place the first buttonhole at the fullest point of the chest or bust and measure up and down from there. It will be less likely to gape.

Shirts and Ties

80. If you doubt the actor's tie-knotting dexterity, tie it yourself, secure with a stitch and cut and make a fastening at the back of the neck.

81. Teach actors how to tie the right knot for the period.

82. Shirt collars on modern men's shirts can be recut to the shapes of other periods while still attached to the shirt. Press the collar flat, cut the new shape, making sure both sides are even and zigzag round the edge with a very close stitch.

83. You can make a new collar from the tail of a shirt if you need matching cloth and bodge the bit that tucks in with any suitable scrap.

Skirts

84. It can look better to shorten a ground length skirt in the front only and leave the back and sides long. The important thing is to make sure it does nor catch on the actress's toes when she walks forward.

85. It is easier for a dancing actress to hold up her train with a loop or ring sewn onto the skirt that she can hook over finger or wrist.

86. Remember to check hemlines from the lowest point of the auditorium and provide suitable underwear if it shows.

87. Its sometimes possible to machine tucks in a skirt waist to take it in and often quicker than moving fastenings.

88. Sew loops of tape at each side of the waist of skirts and bodices to keep them in shape when hanging.

89. Hook short bodices to skirts at the side seams to avoid a gap when arms are lifted.

Trousers

90. Make sure actors know how to hang trousers so that the creases stay sharp – lots don't.

91. If trousers are too short to allow for a turn-up, make a false one with a tuck pressed upward.

92. When adjusting braces, ask the actor to hold the trousers at comfortable crutch level and set the braces accordingly. Make sure they are level.

93. Measure kneebands over a bent leg or they will be too tight to kneel in.

94. Sew up the flies on underpants and pyjama trousers if they are likely to gape on stage.

95. Remind actors unused to fly buttons to do them up.

96. Overfull pockets make hips look lumpy.

WASHING AND CLEANING

97. If possible actors should wear absorbent cotton T-shirts under costumes as they can be washed easily and often. Chop off the neck and sleeves if they show.

98. If you have to use bleach to whiten cloth make sure you rinse it out thoroughly or the cloth will rot.

99. Attach the iron with a cord or tape to the ceiling of the workroom so that it hangs suspended just above the floor should you knock it off the ironing board.

100. Test wash and preshrink fabric before you make costumes that will be washed.

101. It is quickest to iron many fabrics slightly damp. Bundle them into a polythene bag with eggcup or more of water, knot the top, shake and leave it for a few hours and everything will be evenly damp.

102. You can speed up tumble drying small items by putting them in with a big dry bath towel. Everything tumbledries quicker if you shake it halfway through.

103. You can use sticky tape wrapped sticky side out round your hand as a clothes brush or feather collector.

104. You can usually tell if the colour of a fabric will run if you wet a scrap and iron it sandwiched in a piece of white cotton.

105. Wash delicate lace in drawstring muslin bag.

106. Iron fringe by combing it out on the ironing board with a wide toothed comb and following the path of the comb with the iron.

107. Fuller's Earth (available from pharmacies) makes good, clean dust and brushes off easily.

108. Delicate linen or cotton fabrics can be boiled clean in a muslin bag.

109. Powdered starch is cheaper than spray starch and more efficient for large or heavily starched items.

USEFUL TOOLS

In the introduction there is a list of the most essential tools for the costume maker. This is a more exhaustive one. They are not all essential but will make life easier.

Awl or hole punch
Bulldog clip for holding hair, belts, costume alterations, etc., at fittings
Clipboard to use as a portable desk
Clothes brush
Clothes pegs
Drawing pins
Emergency repair kit
Extension lead
Fuse wire assortment for mending jewellery
General purpose glues
Glue gun
Hairband to put up long hair at fittings
Hatpins
Heel grips – little rubber pads to stop heels slipping off
Innersoles – the sort you cut to size
Iron cleaner
Large black marker pen for hiding wear marks
Laundry marker
Magnet for picking up dropped pins
Masking tape
Metal straight edge or ruler for cutting against with a blade
Muslin bag with drawstring for delicate washing and boiling lace
Needles
Notebook

Oil for the sewing machine
Paintbrushes – different sizes
Pens and pencils
Pins
Plug adapter
Rouleaux turner (a long wire with a latch on the end for turning narrow tubes of cloth inside out)
Rulers – one long, one short
Safety pins, including a couple of huge kilt pins
Sandpaper for roughening surfaces for glue
Scalpel or craft knife
Scissors – many pairs for different purposes.
Screwdrivers
Self-adhesive labels
Shoe cleaning equipment
Shoe stretching fluid
Small exhaustive costume reference book
Smooth slim paintbrush handle for poking out holes and corners
Spare shoelaces
Spoon for measuring dye and smoothing glue
Spray starch
Stain removal fluid
Stapler
String
Superglue
Tailor's chalk
Tape measures
Unpicker
Wide tooth comb for fringes of hair and haberdashery
Wire suede brush

INDEX